// TRANSMEDIA 2.0

How to Create an Entertainment Brand using a
Transmedial Approach to Storytelling

Nuno Bernardo

// TRANSMEDIA 2.0

How to Create an Entertainment Brand using a
Transmedial Approach to Storytelling

Avenida Duque D'Ávila, 23
1000-138 Lisboa,
Portugal
Phone: (+351) 21 3100142
Fax: (+351) 21 3100144

The Factory Mezzanine office 3
35a Barrow Street, Dublin 4,
Ireland
Phone: +353 1 4404205
Fax: +351 1 4430639

20 Hanover Square,
London, W1S 1JY,
UK
Phone: +44 208 0992962
Fax: +44 203 1782456

First published by beActive books in April 2014
Copyright © 2014 beActive books / Nuno Bernardo

The moral right of the author has been asserted.

ISBN: 978-1-909547-01-8

beactivemedia.com

First Edition

// TRANSMEDIA 2.0

How to Create an Entertainment Brand using a
Transmedial Approach to Storytelling

Nuno Bernardo

About Nuno Bernardo

Nuno Bernardo is an award winning and Emmy nominated transmedia writer and producer and the creator of the world's first international interactive on-line teen series, Sofia's Diary.

After spending some years in the Marketing and Advertising world, Nuno Bernardo established his own Company, beActive, where he created "Sofia's Diary" (Portugal), a pioneering Interactive TV Series in its mix of traditional medias such as TV, Books and Live Events with new medias such as Internet and Mobile. The Series has been localized in 10 territories around the World and is distributed by Sony Pictures Television.

His pioneering work in this area has lead him to be guest and keynote speaker at International events such as the Toronto, Cannes and Venice International Film Festivals, MIPTV (Cannes), MEM (London), Participation TV (London), the Interactive TV Show Europe, Power to the Pixel, and many others.

In North America he is an executive producer for prime-time TV Series, including "The Line" featuring Linda Hamilton, and "Living in Your Car", which premiered on HBO Canada and was broadcasted in several key territories.

In Brazil Nuno produced the Transmedia series "Final Punishment" which earned him an Emmy and a Rose D' Or nomination and a "TelaViva Best interactive Show" Award and a C21/Frapa Best Multi-platform Format Award. His work as the producer and creator of the series "Aisling Diary" for Irish broadcaster RTE also earned him two Kidscreen awards in New York for "Best Teen Drama".

Nuno's recent work includes The Knot, a feature film with Noel Clarke and Mena Suvari and Beat Girl, a multiplatform property turned into a movie that premiered in European cinemas in 2013. Beat Girl was recently sold to Electus in the US to be remade as a prime time TV series and was nominated to an Emmy as Best Series. He also wrote and produced Collider, a SCI-FI feature film that was released in the fall 2013 and produced the multiplatform documentary "Road to Revolution".

Nuno Bernardo is the author of bestselling book "Producer's Guide to Transmedia", contributes to the MIPWORLD Blog and he is a frequent speaker at the most important industry events and festivals. In his home country, Nuno already sold more than 500.000 books and his work is being licensed for International publishing. According to the BBC, "Nuno Bernardo is a leading world expert in New Media".

 www.facebook.com/transmediaguide

 www.twitter.com/nmfbernardo

CHAPTER I - The Transmedial Approach to Entertainment Branding

- My Take on Building Transmedia Brands :5
- The Rise of the Nanostudio :16
- The New Producer's Role :20

CHAPTER II - Financing Transmedia

- Business vs. Funding Models :27
- First Stage Funding: Development and Incubation :33
- Second Stage Funding: Going Mainstream :36

CHAPTER III - Building Your Storyworld

- Characters are Key :45
- Collider: From Concept to Cross-media Franchise :52
- Creating an Experience vs. Telling a Story :54

CHAPTER IV - Planning Your Release

- Pick the Right Platforms :67
- Pinpointing Your Project's 'Mona Lisa' :69
- The Storycaster :70

CHAPTER V - Marketing

- Build Partnerships, Beat the Noise :79
- Engaging Existing Communities :81
- Build Your Own Communities :87

CHAPTER VI - Monetizing Digital Content

:97
- Creating the Right Context :98
- Transforming Project to Product :103
- Expanding Your Property :104
- Scaling Up

CHAPTER VII - The Future of Transmedia

- More Than a Buzzword :113
- Experience Design :116
- Making the Move from Platform to IP Funding :118
- Global Distribution :119

APPENDIX

- Creating an Indie Movie Franchise Using Transmedia :127
- Transmedia and the Documentary :131

Foreword
by Simon Staffans*

The year 2013 has been a marvelous year for multiplatform storytelling. The reason is simple; there are a lot of platforms to create for, and an ever-increasing amount of people using these platforms.

Back in the days when interactive television was the hot topic of the day, the great challenge was turning a sit-back audience into a lean-forward audience. This is no longer the case. The audience is already very much lean-forward. Not only that, they are leaning forward with a smartphone in one hand, a tablet on the table in front of them and the television turned on - but often largely ignored – in the corner. The challenge now is not to make the audience active, but to offer them engaging and immersive content, a reason to interact and a meaningful direction in which to go.

A great way of approaching the development of immersive and engaging properties is by using transmedia storytelling methods. But still, twenty years after professor Marsha Kinder coined the term, and eight years after the release of Henry Jenkin's "Convergence Culture", transmedia remains an elusive concept.

In a way "transmedia" a bit like the Holy Grail; many a knight of the storytelling table have gone out into the world chasing it. Yet, precious few have touched it and lived to tell the tale – which in storytelling terms means having had their projects accepted widely as true transmedia.

The debate around the term was ongoing for years. As more fields and more industries acknowledge the strengths of using storytelling to get messages through to target audiences, and as the fragmentation of the audience on the technological side becomes increasingly apparent, transmedia has become a term du jour in marketing, advertising, publishing and a number of other industries. Needless to say, not everyone looks at transmedia in the same way.

Still, 2013 offered us a great many projects to feast our eyes on, but what do I look forward to? Well, there are many things to get excited about, from the new humongous productions like Game of Thrones or |The Walking Dead, the next installments in the Avengers and X-Men, and Remedy's attempt to fuse television and Xbox gaming with the Quantum Break series, to following how industries like publishing will continue their work to bridge the gaps to other media fields.

*Simon Staffans is an award-winning Transmedia and cross-media content and format developer and a frequent contributor to MIPBlog.

Introduction

Every producer aspires to design an entertainment brand that can grow into a pop icon, a brand whose storyworld or hero has enough creative potential to power spin-offs and reboots, theme park rides and acres of merchandise. But, how can independents achieve this degree of success if they don't have one hundred million dollars to spend on a marketing campaign or the time to gamble on a one in a million viral video or game. In this book, I will show you how to use a transmedial approach to build an entertainment brand that can conquer audiences, readers and users around the globe and in a myriad of platforms.

Through my own experience producing transmedia with my company beActive, I have developed a step-by-step approach to building long-running multi-platform entertainment brands and loyal viewing communities. I want to share my knowledge with filmmakers, television, games, and digital content producers, marketers and brand managers, audiovisual and media students who want to learn a trick or two about how to use stories and a transmedial approach to marketing and communication to attract audiences and users to their stories and products.

By the end of this book, you will have the practical tools to:

(1) operate more like a small studio by controlling project development, marketing and distribution;
(2) distinguish the three types of transmedia including brand extension or multi-platform media, crossmedia (web series/digital content), and organic transmedia or the transmedia franchise;
(3) develop storytelling techniques agnostic of platform;
(4) build your own fan base, and
(5) create an experience or a context in which people are willing to pay for content.

Why I Fell in Love with Transmedia Storytelling

I. A New Way to Tell an Old Story

In the past decade, transmedia has proved invaluable as a communications strategy. Its real value lies in its prioritization of a dynamic storytelling experience as opposed to a more or less static broadcast. I was eight years old when I heard on the radio a Portuguese remake of Orson Welles' play, War of the Worlds. It was so persuasive in its approach; I was absolutely convinced that an alien force had invaded us.

Decades earlier, Welles first broadcast his adaptation of H. G. Wells' popular novel; the impact it had on audiences was immense. Listeners swamped police switchboards with panicked calls, and some fled their homes. Even though the audience was familiar with Wells' story, they engaged in an unprecedented manner with Welles' use of a popular platform. I was fascinated by the way he made the story function, as a live event, blurring the lines, is a radical way, between fiction and reality. Looking back, I realised that storytelling is as much about the way in which you choose to tell a story as it is about content.

II. Creating Social Connections and Interactive Communities

One of the defining moments of my early career as a writer-producer occurred in 2001 when I was working on a collaborative primetime series with Portugal's TV Cabo and Microsoft. At the time, Microsoft was exploring the technical feasibility of interactive television and they were road-testing their products in Portugal before launching a product to a global audience. As the project progressed, I became more and more interested in how different types of content attract different types of audiences and illicit particular responses. When you present your audience with a format that is slightly more engaging than the typical television series, more often than not they'll form an emotional connection to the narrative and respond to it in a way that is both more profound and enduring.

The interactive card game we'd developed to promote an existing TV show is a case in point. The multi-player game employed a simplistic design and allowed each player to interact with the game itself as well as other audience members. Players could challenge other individuals in the viewing community, partner up with other players, and chat. Over time, the game became more successful than its primetime counterpart because its players could interact with one another and actively participate with the content. This social element created a sense of conversation amongst the players, which enriched their experience and spurred further interaction. The game's success convinced me that, in a world saturated with media, you can still capture an audience by telling your story in a way that brings people together.

Storytelling is a social experience. We've been telling stories for millennia to establish connections between others and ourselves and to make sense of the world around us. As producers, we shouldn't forget how important this need to interact and participate is to telling and experiencing a story. The most affective stories therefore are inclusive, not exclusive. They create a community of viewers engaged in ongoing dialogue. Unlike the 'choose your own adventure' style of storytelling, transmedia enriches story by activating the human affinity toward shared experience. Whatever your take on a television show or film, that perception is enhanced in conversation when you can share and revisit the story with someone else. Certainly one of the pleasures of watching a big name show is the opportunity for discourse it creates. Mad Men is all the more relevant to me if my friends or coworkers are always watching it and we can discuss the show collectively. Before the age of digital media, when you watched a television show, you could only talk

with the person beside you on the couch, over the telephone, or at work the following day. It was impossible to have the sort of global, real-time conversations we have routinely today. When I was in school, for instance, I would tune in to watch the latest hit animated show at six p.m., but I would have to wait until the following day to chat with my friends about it, and even then my voice was limited to a very localised audience – my classmates.

The interactive TV card game mentioned above was ground breaking in that allowed players to communicate remotely in real time with people they more than likely did not know. The actuality of the story was made all the more palpable by its ability to create the occasion for conversation between strangers. Nowadays, new digital technologies and social media have created platforms through which communication between individuals and audiences occurs on a global scale in real time.

III. 'Push' the Audience and Promote Interaction

The social impetus for storytelling has not changed—people have been sharing information and engaging one another for millennia—but now we have virtually unlimited access to audiences across the planet. We can strike up a conversation with friends and strangers alike while we're watching a television show or a webisode or playing a console game. This shift is critical to transmedia producers because it allows us to grow a global audience rapidly, which we can engage in real time.

My interest in exploring this shift through transmedia was further galvanised at the 2001 MILIA in Cannes. The gaming powerhouse Electronic Arts was poised to launch an alternate reality game called Majestic, one of the first of its kind. Inspired by the 1997 film The Game starring Michael Douglas, Majestic engaged the player in his private sphere, even after he'd discontinued play. The program would continue to prompt player interaction by calling him at his office or emailing his personal email account. Through these extra-play engagements, Majestic took on the mystique of an independent, living entity, hence the tagline 'It plays you.' My encounter with Majestic inspired me to pursue a more proactive approach to storytelling. I began to realise that a story or a game does not have to be a passive entity; in the right format, content can actively engage its audience.

Sofia's Diary grew out of my desire to create a character that behaved like a real person and who's story we could promote through push tools and other modes of audience interaction. Based on the diary entries and day-to-day dramas of a teenage girl, Sofia's Diary is, by no means, ground-breaking in its premise. Instead of attempting to create a novel storyline, my intention was to tell a conventional story in an unconventional way, like Orson Welles did decades prior. Using a host of different platforms including mobile phone applications, blogs, and magazine columns, we were able to create a three-dimensional experience for our audience. To underscore key plot points, we used SMS to send text alerts from 'Sofia' to audience members. On her way home from school, she might text her virtual friends saying, 'I just broke up with my boyfriend. I can't say anymore now, but as soon as I get home, I'll update my blog and give you all the

details.' By using multiple platforms cooperatively, we were able to simulate the effect of the Sofia's story happening in real time in a story world parallel to the audience's.

When I began to shop around the series promo in 2002 to broadcasters, mobile operators, and portals I wasn't aware of the potential for developing a crossmedia property or the ways audiences' viewing habits were changing, especially with regard to television. I did know that it didn't make sense to limit the story to any one platform; internet and mobile usage was exploding, particularly amongst teenagers and young adults. If we used these platforms, we could tell the stories we wanted to tell without the limitations of television formatting.

After I'd received more than twenty rejection letters and emails, I decided to develop the property at my own risk. Within the year, we were able to launch elements of Sofia's story across three different platforms, including a first person blog, a column in a popular teen magazine, and various interactive services for mobile devices.

The self-funded transmedial approach we adopted allowed Sofia's story to grow into a mass-market phenomenon. The television series became one of the highest rated shows on Portugal's public broadcaster RTP, and the sixteen volume book series sold nearly half a million copies. In 2006, we were able to license the property internationally; Sofia's Diary is now available in ten territories across the globe.

The process of developing Sofia independently of the industry's conventional channels made very clear to me the challenges that face transmedia producers. First and foremost, your audience and potential sponsors will expect you to understand and access multiple storytelling devices, languages, and formats. You'll be responsible for undertaking every aspect of your project's development from content writing, social media, and gaming to marketing and distribution, and you'll have absolutely no guarantee of financial return. What's more, you will be releasing your content into a market you'll be already flooded with an overwhelming amount of 'noise.'

To seed you project online, it will be necessary to take on significant risks, investing your own time and capital, but in my experience the potential advantages far outweigh these preliminary liabilities. When Sofia's Diary was rejected, I was willing to take the risk of developing the property across non-traditional platforms without the security of a commission. The experience taught me an invaluable lesson in turning what I had perceived as adversity into an advantage. I realised that I could choose to continue working for broadcasters as a service provider, or I could endeavor to make transmedia work for me.

If one of the broadcasters I'd approached had in fact commissioned Sofia's Diary, it would probably exist as a stand along TV show in one territory. While this would certainly be a success in itself, a self-funded, cross-medial approach was the best fit for Sofia. It allowed the multitude of small stories that constitute the brand to grow into a mass-market phenomenon.

By bypassing traditional paths of transmission—major broadcasters and publishers, distributors and marketers—you retain control over all of the elements of your property. You'll also maintain most if not all of the rights to your intellectual property. Down the line, you'll be able to cash in on more substantial revenues by adding content to the franchise and securing licensing deals.

If the world is on demand, which is to say that certain formats no longer command a pre-built audience, producers need to shift their tactics to match the changing habits of their audience. Device no longer defines content; the manner in which it is consumed does. Accordingly, content producers need to create platforms and media that prioritise the demands of the consumer rather than the device(s) they use to access content.

CHAPTER I - The Transmedial Approach to Entertainment Branding

- My Take on Building Transmedia Brands
- The Rise of the Nanostudio
- The New Producer's Role

My Take on Building Transmedia Brands

The concept of transmedia production, as both a creative template and business model, is by no means a novel one. The film industry began using cross-media techniques in 1911; front runners like Walt Disney Studios have been producing complementary content across multiple platforms for decades. So why the sudden upswing in industry chatter RE: transmedia? Because the device no longer defines the media experience it's consumed on. Today's audiences are in a position to choose the content they want to consume when they want to consume it on the device of their choice. In other words the expectation contemporary audience's presume you'll meet is any content, anywhere.

In the context of a shrinking market populated by increasingly fragmented audiences, transmedia provides a viable alternative to the conventional rationale of pitch and produce or perish.

Industry commentators are notorious for using buzzwords like multi-platform, cross-media, transmedia more or less interchangeably. As a creative and commercial practice, transmedia is still very much in its infancy. The industry is at pains to define the phenomenon even as it's evolving. To my mind, true transmedia describes a storytelling process that employs individual, complementary media that permeates the daily life of the audience and allows for personal interaction and participation. To achieve this sort of active engagement, transmedia incorporates a range of entry points across various platforms; each entry point provides the viewer with a unique perspective of the overall story.

Three Genres, Three Goals

There are, in reality, several different production techniques that fall under the general rubric of transmedia. Each mode has a unique end goal and development process. In this book, I would like to differentiate my own transmedial praxis from other multi-platform genres to demonstrate my strategy for building successful brand franchises.

Genre 1: The Brand Extension

Brand extension is the most established form of transmedia and involves a studio or television network producing complimentary content across multiple platforms to promote a core product such as a feature film or a TV series. The audience is given access to additionally information—prequels, back-stories, alternate endings, for example—via the web, social media, and mobile applications.

Unlike other forms of transmedia, the priority of brand extension is the core product. Audiences may have access to alternative content and applications, but these aspects are secondary to the feature film or the television series. They act as a gateway, which leads the audience back to the core brand. Transmedia purists argue that brand extension is nothing more than a marketing tool. The extension is not a stand-alone produce per say. It's intended to drive ticket sales and boost audience numbers. The television series or film it's based on remains the content's anchor point.

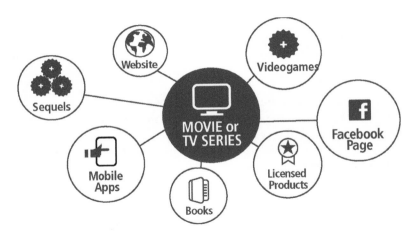

Figure 1. The brand extension concept.

One of the issues of this approach is brand consistency. For example, the web and mobile spin-offs of the hit series 24 did not live up to the audience's expectations because they were not integral to the quality or styling of the series brand. The original show is action driven; it's well shot and boasts a superb cast. When viewers saw the brand on mobile and web platforms, they expected the same level of quality. Unfortunately, both The Rookie and 24: Conspiracy were low-budget productions populated by unknown actors. The quality of these products was so inferior to the original series, fans rejected them.

Throughout the 90s and the 00s, you could count on Hollywood to follow up a blockbuster movie with a console game. Like the 24 brand extensions, these games tended to feature shoddy animation and character voice-overs from no name actors and not the best game and level design. The players knew that the games were sub-products; their

producers hadn't made the effort to make a high quality game. They were merely cashing in on their brand.

To be successful, brand extensions must keep integrity with its originating context. Nowadays, producers develop games using high-spec graphics, additional plot lines, and the voice talent of their lead actors and actresses. James Bond 007: Bloodstone features the likenesses and voices of stars Daniel Craig and Judi Dench, for instance. The plot-line is completely original and was penned by Goldeneye co-writer Bruce Feirstein.

This sort of high profile brand extension functions as an additional layer of context that enhances the franchise experience. These products have proved tremendously successful in promoting big budget Hollywood productions. While many purists argue that brand extension is not authentic transmedia but just digital marketing, it should be acknowledged for its unquestionable capacity as a marketing tool. It gives producers the ability to connect with a wider audience while generating additional revenue streams and promoting the core brand.

Genre 2: The Stepping Stone

Smaller production companies without the financial backing of Hollywood studios may decide to produce their series or game for online consumption only. By using a single digital platform, the producer is able to reach a specialized audience while keeping his costs at a minimum. Webisodes (video content produced for the web in a serialized short form) and mobisodes (video content produced for mobile phones in a similarly condensed format) have become extremely popular in Europe and the United States in recent years. The digital video short remains a stand-alone industry with its own standards and awards—the Webbys.

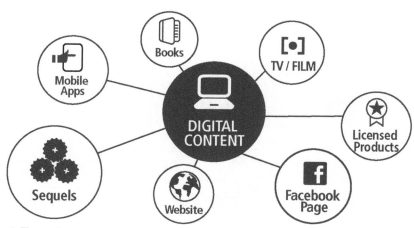

Figure 2. The stepping stone concept.

In many cases, these projects are intended as prequels to successful films or television series. Alternatively, they are produced exclusively for online consumption and are

monetized through advertising partnerships. The producer of this type of content will focus on one core digital product and hope for the best. If that product succeeds in its original platform, it can then be transformed into a transmedia brand. The vast majority of webisodes and mobisodes do not succeed in making the transition from digital to mainstream media, and more often than not, online advertising revenues are insufficient to support sustain such a project as a stand-alone entity. There are, however, exceptions to the rule. Finnish games company Rovio struck gold with Angry Birds in 2009; the game has since become one of the most widely used mobile apps across the globe. Rovio is currently in the process of translating Angry Birds into a successful franchise complete with toys and confectionary, theme park rides and a feature film.

The biggest challenge webisode/mobisode producers will face is making the transition from digital to mainstream media. Content produced for online or mobile consumption does not require intensive concept, character, or plot development. If the series does become a hit, in the time it takes to translate it into a successful television series the audience will more than likely have moved on to 'the next big thing.' Angry Birds went viral four years ago, and Rovio's follow up television series is slated for debut nearly four years later. To ensure that you don't lose your audience to the 'next big thing,' it is essential that you plan a multi-platform business strategy so that you'll be able to feed your audience an unbroken stream of content. In chapter III, I will go into greater detail with regards to developing your project and the importance of building a storyworld from the beginning.

Genre 3: Organic Transmedia

Organic transmedia is the approach that most accurately describes my own work practice with beActive. The best way to describe this approach is storytelling agnostic of platform. When we are developing a storyworld, we allow cross-platform activity to grow organically from inside the story. The process is story-centric, not platform-centric.

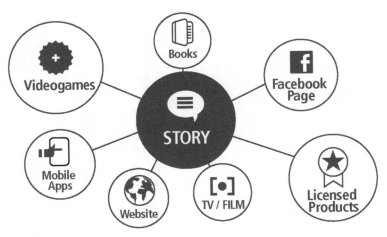

Figure 3. The organic transmedia concept.

Storyline and cross-platform applications evolve in tandem, preventing the latter from becoming an add-on or gimmick. They are, rather, generated by storyline itself.

When we were developing the multi-platform property Collider, our aim was to create a storyworld and then divide that narrative universe into complementary but self-contained platforms. Collider is an Emmy nominated, sci-fi thriller that follows the lives six characters who've been transported to a post-apocalyptic future. To save themselves and the rest of mankind, they must find a way to return to the present. We began developing the project in 2009 with little more than a concept for a story that was somewhere between ABC's Lost and the Schwarzenegger hit The Terminator. After three years of development, we rolled out a complete multi-platform property, which includes six comic books (one per character), a graphic novel, a web series, games, and a feature film.

Every element of the Collider project was released according to a pre-planned distribution strategy and time-line. We paid particular attention to the way each piece of content was created as it needed to function as both a self contained products (for the single platform audience) as well as a complimentary product (for the multi-platform audience). Organic transmedia allows the producer to incubate a story or character online and involve his audience in the development process in real time. It is important to bear in mind that the purpose of cross-platform activity isn't primarily for the purposes of marketing. The most effective transmedial brands are intent upon creating a richer, more interactive experience for the audience.

To illustrate the merits as well as the challenges of adopting an organic approach to transmedia, I will discuss the successes and failure of my projects from Sofia's Diary, Beat Generation, Flatmates, and Final Punishment to Aisling's Diary, Beat Girl, and Collider.

Creating a Brand: The Essentials

(i) Well Developed Characters

One of the most important aspects of a developing a transmedia project is creating compelling characters. Successful characters are three-dimensional; they live alongside the viewer and engage with them in a manner that is both practicably and emotionally authentic. If, for instance, your characters are interacting with your audience on Facebook, Twitter, or other social media, they need to be sufficiently developed to be believable and engaging. Even with a relatively straight forward plotline, well developed, 'true' characters are what sustain a project across multiple platforms.

(ii) Building Your Storyworld

Once I have developed a project's central characters and plotline, I being constructing the Storyworld—the subplot lines, minor characters, and back stories—around these primary characters. A clearly defined storyworld and project 'bible' will help you to identify the most appropriate platforms or media for your narrative. I would recommend you develop your characters and Storyworld agnostic of platform so as not to prioritise one media over another. Where the conventional branding models place the movie script or television series at the centre of the development strategy, the transmedia approach places the storyworld and the project 'bible' at the centre.

(iii) Test Your Story With a Real Audience

Today, the transmedia storyteller or producer has direct contact with his audience. In the early stages of a project's development when the characters and plotlines are taking shape, I usually release an aspect of this content online to gauge which elements of the narrative resonate with the audience. This real-time feedback is invaluable to the development of your project; it allows you to pinpoint which characters your audience relates to and which plotlines resonate with them in order to determine where best to invest your resources. During this 'incubation' period, I recommend using audience feedback to fine tune your product.

(iv) Identifying Suitable Platforms for Your Story

Planning and prepping for the expansion of your story to other media is central to the transmedial approach. Not all content is suited for translation to every platform, so it's imperative that you identify which types of media to use to tell different aspects of your story. You also need to consider how you will make the transition from one form of media to another while insuring that your brand maintains narrative and tonal consistency across all platforms.

(v) Develop a Distribution Timeline

Once you have designed a menu of platforms or media where your story will 'live', you need to establish a distribution strategy or timeline. Launching your story on each of your designated platforms simultaneously probably won't make sense. If you want your characters and story universe to feel authentic, it is crucial to generate a distribution timeline. When we were developing the Collider brand, we grew an initial fan base using social media on the Internet and via mobile applications to created a context for audience participation.

From day one dedicate the resources you do have to create a product you can launch online and begin building your audience. Whether it's an ebook or a casual

game, seed the content online for free using your own funds. Consider this product your first proof of concept; if it works, invest more money into developing free content for a second platform that introduces your story to a wider audience.

Once you've established an audience, consider applying for R&D grants and soliciting funders for venture capital. Adapt the story to a third and fourth platform, depending on the traction you've attained online. Think of each platform shift as a built in reality check; try to create the simplest path possible to your 'big product.' Is your audience following the story across media? If they are, you should then approach a broadcaster, publisher, and/or film board and sell your product as premium, saleable content. If you're successful, this is the second proof of concept. Now you have the capital and the audience to sustain the production of your 'big product': a feature film, a television series, or a triple-A (or console) videogame.

1st Platform & Proof of Concept	2nd Platform	3rd Platform	4th Platform	5th Platform	BIG PRODUCT 'Mona Lisa'
eBook	Graphic Novel, Comic	Web Series	Game, App	Paperback Book	Feature Film, Television Series

SPEND MORE $, EXPECT MORE REVENUES

| Month 1 | Month 6 | Month 12 | Month 18 |

Figure 4. Releasing plan for a transmedia property.

———————————————BUZZ CREATION————————————————»

Niche Market Mainstream

(vi) Audience: Your best asset

With the advent of digital publishing, producers can now 'own' their audience. They can initiate a dialogue with individual viewers and find out what they like (or dislike) about their story. Road testing your product with an audience prior to a major release provides you with another distinct advantage—promotional leverage. An active product with an established fan base is much more attractive to potential partners or funding bodies. Investors are much more interested in talking with you if you can demonstrate that you have already established a following.

Audience Experience

When you're developing a business model for your project, it is important to keep in mind that people do not simply buy content. They buy into an experience. A successful product creates the right experience for the right audience. With so much content available to audiences free of charge, it is important to consider which sorts of experiences audiences are willing to pay for.

It is essential that we, as storytellers, invest in the audiences' experience. Depending on the what the consumer wants at the moment he logs onto a website or flicks on the television, his experience will be either passive or interactive. I tend to classify these two modes as the 'lean back' or 'lean forward experience.' In the former, the audience leans back from the screen and consumes content in a fairly passive manner. Alternately, lean forward content is designed to draw the audience close to the screen, and engage them in multiple layers of interactive media.

Be sure to keep in mind how audiences engage different types of media when considering the design of your storyworld experience. How might you take advantage of viewer habits to prompt active engagement? At which points should you position lean back elements? The trick is to find a balance between interactive and more traditional modes of storytelling that will reward your audience for their participation without overwhelming them.

Another key factor to consider when designing your transmedia experience is why people choose to engage with a particular piece of content and the communities associated with it. There are five principle reasons why we engage with content; recognising each of these factors will help you decide what sort of content to create and which platforms to utilise in order to attract and sustain your target audience.

(i) Peer Status

Audiences are drawn to products that resonate with and reinforce their own sense of identity. The majority of teenagers, for instance, will not pay to download music online, but they will pay a significant amount of money (three or four euros) for a thirty second ring tone version of their favourite song. The content functions as an extension of the individual; it appeals to their ego. The more points I post on an online leader board, the more apt I will be to continue playing because my high score elevates my status in the community. Likewise, products which function as status symbols, like showy brand name clothes, are made all the more popular by the status they imply within the content of a niche group.

Like peer status, a brand's exclusivity factor also adds to its allure by underlining or supplementing an individual's sense of self. When consumers perceive a brand as exclusive to their experience, their engagement on and offline becomes all the more

personal. For example, when Sofia's Diary crossed over from online platforms to television, the fans, which had discovered and nurtured the character on the Internet, were ecstatic. Sofia had grown from a relatively obscure persona who connected people with similar interests and ideas to a mainstream icon.

When you're working to promote and grow your property, keep in mind that you are building a niche community that defines itself in terms of your content. Engaging that community to its full potential means creating contexts, which encourage more and more interaction from both casual and uber fans. There are two psychological forces at work here: (1) the need to define the self against the mainstream and (2) the need to distinguish the self within a peer group.

Star Wars fans, for instance, constitute a tremendous niche community with uber fans frequenting ComicCons across the globe. Everyone wants to have the coolest costume; they want to be the one who is photographed the most, talked about, 'liked' and 'shared.' In similar fashion, big users of online content want to be recognised as markers and opinion makers within their community. These are the users who post the most content and make the most comments in order to augment their status amongst their peers.

Keep in mind that the pieces of content a viewer will access have more to do with what his friends are doing via social media than with what a media portal might recommend. Your viewers and the social media on which they consume and interact, therefore, have immense marketing value.

(ii) Prizes/Awards

A more direct way to motivate your audience to participate with your content is to offer them prizes, such as merchandise or exclusive tickets to a live event, or community-wide awards, such as a rank in a leader board or the publication of user generated content or fan fiction. Competitions are easy to stage online and very simple for your fans to follow. They spend five to ten minutes with your content, answer a trivia question, snap a photo or post a comment, and they have a chance to win a prize.

(iii) Entertainment Value

Don't underestimate the value of an easy laugh. A product, which is entertaining or fun, will more than likely attract a crowd. Look at the success of the Korean pop song 'Gangnam Style', the first online video to record over one billion hits, which earned eight million US dollars in advertising revenue. Establishing a following online may not yield profits right away, but it will certainly provide you with the leverage necessary to approach investors with your product.

(iv) The Cause

Similarly, people love to back up a worthy cause; a well-presented initiative has the potential to attract a global following. The short documentary film Kony 2012, for example, elicited a far-reaching awareness campaign that included such personalities as George Clooney and Taylor Swift.

To promote the Collider feature, we designed a Facebook fan page called the 'Collider Movement.' The page incorporates interactive content, which is geared toward four of the five engagement incentives. These activities are subdivided into four tabs: 'Missions', 'Leader Board', 'Rewards', and 'Goals'.

The overall function of the 'Collider Movement' is to enlist fans to help beActive and the Collider community spread the word about the film. They're invited to 'like' content, share links and post comments in order to achieve specific goals. Each 'mission,' for instance, has a three prong purpose: to entertain the audience with interactive dramas drawn from the Collider storyworld, to offer tangible prizes for completing relatively straightforward tasks and to enhance the peer status of top tier engagers by awarding points and leader board rankings for specific interactions.

Keep in mind that there are various levels of engagement. We designed the 'Collider Movement' to reward every audience member, from first time visitors to die-hard fans. While one viewer may be interested in growing his voice within the Collider community or winning a ticket to the film premiere, another may be motivated purely by his desire to play a casual online game or contribute to the movement's 'cause.' By designing an experience that appeals to a host of audience motivations, you can affect a higher rate of return viewing and overall visibility.

(v) Relatable Characters

Approachable, charismatic characters are key to the long-term appeal of a transmedia franchise. The success of Sofia's Diary, for example, came down to the relatability of the title character. Teens were motivated to tune in to and interact with the show because Sofia was a character they could envision as a neighbor or a friend—someone with interests and problems similar to their own. Strong, accessible characters are vital to establishing connections with your audience which are often more profound and lasting than the property's entertainment value or its transmission of peer status.

Traditional Media vs. Digital Media

The June 2012 issue of Broadcast magazine featured a headline that heralded the end of the 'era of digital pennies.' For more than a decade, established studios, producers

and broadcasters have considered digital media as the bastard son of the entertainment industry. The Internet and, later, social media and mobile content were cheered as innovations that were exciting and cool but ultimately incapable of generating revenue. Industry gurus classified the maximum potential of digital media in terms of marketing revenues, which were insignificant when compared to the profit margins of possible in television and film.

Nevertheless, many digital projects have succeeded in capturing new audiences by adapting to and anticipating their viewing preferences as well as the attention of mainstream media outlets and renowned producers. Properties like our own Sofia's Diary to EQAL Media's LG15, Felicia's Day's The Guild and the recently launched Halo web series have made global headlines, and yet industry professionals and executives persist in nay-saying, ever keen to point out the number of companies that have attempted a transmedial approach and subsequently disappeared. The industry's love/hate relationship with new media extends to the major Hollywood studios who seem to begrudge their own digital departments while acquiring external new media companies, merging and then closing them.

But the polarities between traditional and new media are changing. When, recently, I spent several weeks in meetings in Los Angeles, I could sense that the market has matured. Investors are more cautious than in the past and, more importantly, new funding models and sources are being used to generate the necessary revenues to sustain this activity. Not only are major video platforms like YouTube, Hulu, Yahoo and Netflix beginning to commission original productions, they're also offering producers advances on future revenues. The key elements of any international television or film funding plan are distributors' advances and MGs (minimum guarantees against future revenues); at last, this template is being applied to new and transmedia productions.

Recently, big stars are taking advantage of revenues available through crowd funding initiatives. Zach Braff raised $3.1 million US dollars in a kickstarter.com campaign to fund the second film in the Garden State franchise, Wish I Was Here. Rob Thomas, the director of the teen detective series Veronica Mars, has raised nearly $6 million US dollars through crowd funding in support of a spin-off feature. Big names will always draw more support from their fan bases, but crowd funding remains a viable source of seed revenue for independents.

Now that digital platforms are more open to fronting money to producers and talent, a new breed of digital-only content is starting to appear, and the companies behind these properties are beginning to prosper. New digital projects are becoming not only crowd pleasers but also sustainable businesses. More now than ever, producers are structuring their resources and work flows to support the extension of their audiovisual properties and entertainment brands to multiple platforms, exploiting the billion dollar industry of mobile applications or digital paid downloads (in the form of videos, audio, or ebooks) to increase their bottom line. The paychecks these digital portals and

platforms are writing to content producers each month have swelled from pennies to hundreds of thousands of dollars.

These breakthrough opportunities are key to the development of the burgeoning industry of digital, cross-media or transmedia content—whatever you choose to call it. Audiences have already embraced these platforms, and now it's time for the entertainment industry to adapt its business models so that they parallel audience behaviors. Youtube networks like Machinima.com attract a daily viewership that eclipses the majority of television networks worldwide. There are web series that boast viewer ratings which surpass top prime time shows. Within the TV industry itself, VoD, mobile, Internet and prerecorded viewership now counts for almost half of an episode's total audience.

The Rise of the Nanostudio

Fortunately, today's producers have accessibility to new, digital media and are no longer limited by industry 'gate keepers.' In effect, independent production companies can act as nanostudios, producing and distributing their own content via digital networks.

The breakdown of the studio model begs the question: how, in the age of new media, do we define a production company? Until now, independent production companies operated as service providers who produced creative content and solicited the financial support of broadcasters, film boards, film funds and private investors. The company would sell a concept to a funder for an advance fee, create the content for television or film, and cash in on the production fees. The company would then transfer their product to a distribution company and, if it was successful, earn further revenue in the form of royalties. Within this frame, the producer's ambition is to create more and more salable content and make a living almost exclusively off of production fees.

By definition, the studio model mirrors the industrial production line. Teams of content creators and technologists are kept in house to keep the machine rolling; at all times, the house has a project in development, production and post-production and produces ten to twenty films a year. The company makes money on some and loses money on others, but at the end of the day, they make a profit. They then pay their shareholders and use surplus profits to invest in new projects. Their aim is to continue to build their portfolios while improving their production techniques and business model so that they'll have more control over different elements of the production process and distribution process.

One of the advantages of a transmedial approach is that it allows small production companies to control the marketing and distribution of their own content. Transmedia nanostudios can green light their own projects as well as promote and disseminate their own content by dealing directly with their audiences. By taking control of marketing and

distribution, transmedia producers keep ownership of their properties' rights; they do not need to reassign rights to sales agents and distribution companies in order to get their products to an audience. This process allows small companies to build a library of titles (like the major Hollywood studios), each with its own audience and cash flow which provides them with the revenues necessary to cover overhead expenses and invest in new projects.

More and more, blockbuster movies are funded through private equity from investment funds. For instance Legendary Pictures has funded dozens of films in partnership with Warner Brothers, and Ryan Kavanaugh's Relativity Media has done the same with the likes of Columbia and Universal. These types of mega-films cost hundreds of millions to produce and as much to promote, which poses a big risk for the studio, so they pitch their projects to private equity funders like Kavanaugh. The studio knows how to make these types of movies and how to promote them; they invite funders to invest in the enterprise that is releasing a blockbuster movie in exchange for shares in the profits.

Studio credibility is vitally important for one reason in particular: the studio controls its own means of distribution. Typically private equity funders do not want to invest in independent movies, especially in Europe, because the majority of these films never reach an audience outside the festival circuit. If they invest in a production with an entity that is not a studio, they have no way of knowing whether or not they'll be able to recoup their investment because there are no guarantees that the movie will be distributed across several territories.

Alternatively, when they invest with a studio, they're investing in the entire enterprise of production, marketing and distribution. The studio can guarantee that the movie will be shown in various territories across the globe. Investors know that it will be exploited in theatres, on DVD and on demand.

You may have a brilliant film in production, but if you don't control the distribution and the marketing of your project, you cannot guarantee funders that it will reach an audience. Investors want to be sure they're putting their money behind something that will reach an audience, one way or another.

Nowadays, Hollywood studios are organised by a fairly standard model.

The Twenty-First Century Studio Model:

(i) Library of past productions generates steady income which allows studio to cover overhead costs, e.g. licensing of TV broadcasts, DVDs, etc

(ii) Credibility allows studios to attract private equity investment which reduces immediate risks; co-fund blockbuster type productions which cost $200,000,000 to produce

(iii) Pre-sales and distribution further reduce producer's risk

(iv) Marketing, public relations and distribution controlled in-house

In Europe, there are no studios comparable to those in Hollywood that control pan-European production, with the exception of Working Title (which is now owned by Universal) and EuropaCorp (which has a longstanding relationship with Twentieth Century Fox). Even though neither of these companies controls the distribution of their content globally, they have succeeded in brokering deals with larger companies based on their productions' critical acclaim and salability. As successful as Working Title and EuropaCorp are, they still need to work with Hollywood in order to see their work distributed globally.

The biggest problem facing European independents is the fact that they do not own the majority of the rights to the films in their libraries nor do they control their distribution. As a result of having to raise one hundred percent of their production budgets for each project they undertake, European companies are forced to co-produce with other companies or solicit the support of local film boards or private equity investors who then own a percentage of the property's rights.

The problem has its source in unwieldy production models; national film boards will only allocate money to production companies who have established a deal with a sales agency. In exchange for a minimum guarantee or an advance, producers assign all of their film's rights to the sales agent thereby relinquishing control of the properties distribution. Even though you may want your film to be distributed globally, you must wait for the sales agent to sell your content on a territory-by-territory basis. What's more, sales agencies tend to accrue immense catalogues of titles, so your particular agent may have twenty other films similar to yours. If he does not see immediate sales what little belief he may have had in your work will evaporate, and he won't make an effort to distribute it further. The film is left to stagnate in the agency's catalogue when it could be generating revenues.

Unlike Hollywood studios, European independents must generate a production model on a project-by-project basis because they can only produce a film if they get the funding from third parties. When they do secure backing and produce a film, they must reassign almost all of their work's rights to external companies in order to facilitate the distribution and marketing of their work. The rights to any one film are so fractured that it's very difficult for independents to promote or generate revenues off of their work or embrace pan-European digital distribution.

For financial reasons, they reassign distribution and copyright at the beginning of the development process. They tend not receive royalties for their work because these movies usually don't attract big crowds and second it is majority owned by other entities, so producers usually are the last in the recoup list. Without a catalogue that

generates continuous revenues, the next time they attempt to produce a movie they must invent their production model all over again.

Let's say a German producer sets out to shoot the indie of the decade. To fund the project, he forfeits the majority of the film's rights to the national film board and several co-producers. He then assigns distribution rights to a sales agent in Paris. Of course this German producer wants to see his film in every theatre across Europe, but he no longer controls how his film is distributed or how its rights are sold. More than likely, his film will languish in a file in someone's office when it could be generating revenue.

Sales agencies and distribution companies continue to work on an obsolete territory-based system. They sell the rights to a film first to cinemas, then to DVD manufacturers, then premium television channels and finally standard TV channels. This outmoded Windows system restricts the producer's ability to disseminate his own work. You'd like to make the film available via iTunes so that it can be accessed and purchased worldwide, but the sales agent you've assigned the majority of your film's rights to operates on a territory by territory, media by media sales model. It's very difficult to generate revenues across the globe using this model.

beActive's production model, on the other hand, has more in common with the conventional studio model. We fund the early stages of development and production with revenues from past projects including Sofia's Diary and Flatmates. The revenue streams we've established through licensing and sub-licensing our productions allows us to invest in new projects that will generate more revenue down the line and allow us to continue to grow our library.

To be successful in the digital age, independents in Europe and abroad need to shift their production paradigm from a single to a multi-platform approach in which they retain control over the development, marketing and distribution of their entertainment properties. Our transmedial approach addresses the issues facing today's independents by adopting a more integrated studio approach which inverts the industry's prevailing business model. Typically, independent transmedia producers invest their own capital to develop a product in its earliest stages, foregoing the traditional advance from a substantial sponsor, such as a broadcaster or a studio, for smaller, intermittent payments from a range of digital partners.

beActive's Transmedia Nanostudio Model:

(i) Early-development funding sourced independently from film funds, private equity and/or revenues drawn from catalogue of existing titles (Sofia's Diary, Flatmates, etc.)

(ii) Develop storyworld/multiple platform content and seed online with big partners who can ensure global digital distribution (YouTube, Wattpad, Machinima.com etc.)

(iii) Sales are driven through premium content and/or advertising

(iv) Depth of storyworld and the longevity of brand ensure sustained revenue

The inevitability of down-scaled typically deferred revenues has led many producers to assume there's no money to be made in transmedia. This is not the case. One distinct advantage to transmedial storytelling is having the ability to function as a nanostudio; you have complete control in shaping your own content, deciding which platforms to employ, when each will be distributed, whether or not you want to merchandise your brand, and which territories you want to market to. While there is certainly more work involved being a transmedia producer, the opportunities to monetize your brand are much greater. Since 2003, I have produced six successful entertainment brands using the nanostudio model: Sofia's Diary, Beat Generation, Flatmates, Aisling's Diary, Beat Girl, and Collider that are now distributed at an international level across several platforms.

The New Producer's Role

Traditionally the role of the independent producer has been to act as a service provider for a broadcaster or network who ultimately owns the producer's commissioned property. In this context, the broadcaster maintains creative and editorial control throughout the project's development. Additionally, they supervise the property's marketing and distribution and recoup the financial gains. What's more, broadcasters are increasingly shying away from commissioning new or independent producers and are choosing, instead, to work with well-established production companies.

The studio model mirrors the conventions of old Hollywood in which the studio retains complete control over their products. Hollywood studios were able to 'green light' their own projects and were in command of their marketing, distribution, and cash flow. I advocate an alternative approach whereby the independent producer operates like a nanostudio.

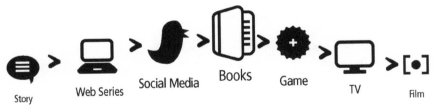

Story Web Series Social Media Books Game TV Film

Figure 5. Growing your brand: from the web to the big screen.

This is by no means an easy route to take; it requires a substantial amount of labor and innovation. You'll need to have the resources to either write or source good scripts as well as the instincts and market savvy to know when to green light the project. You'll have to develop and produce content for multiple platforms and understand how best to utilise each one. Your research and marketing skill set needs to rival those of Disney and McDonalds and your product design and innovation those of Apple—and all with a shrinking budget and a team of two to five people.

The nanostudio model is not intended for contemporary Hollywood. For these producers, the feature film or the prime-time TV Show is still the central product; deviation occurs solely for marketing purposes. The nanostudio model is designed for the up and coming independent who wants to create a successful product across multiple platforms for a new international marketplace and new digital connected audiences.

CHAPTER II - Financing Transmedia

- Business vs. Funding Models
- First Stage Funding: Development and Incubation
- Second Stage Funding: Going Mainstream

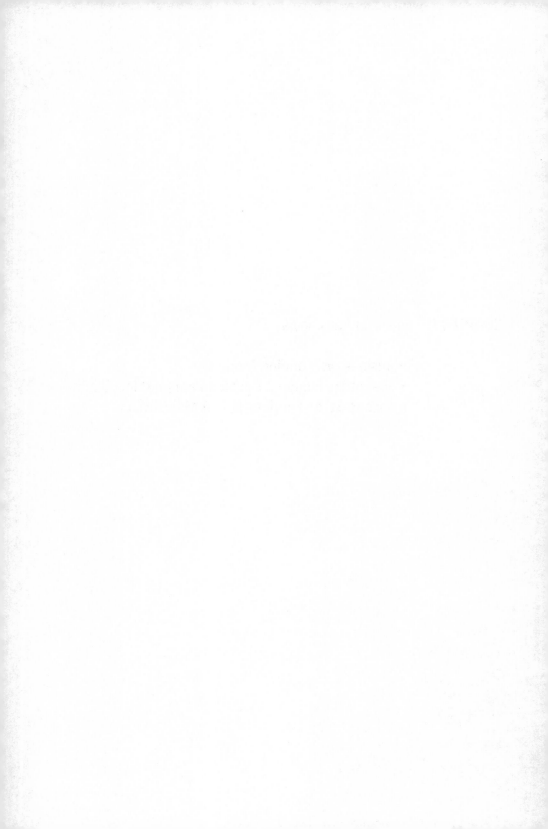

Business vs. Funding Models

Recently, I gave a presentation at a Power to the Pixel event in London on the subject of financing transmedia. When founder and CEO of PttP, Liz Rosenthal, invited me to be a part of her line-up, she requested that I discuss the business models I had applied to my cross-media and multi-platform production throughout the past decade. I agreed, but after I'd hung up the phone, I began to question whether or not I was the right person to speak on the subject. After all, I'm not a financier.

How best to make money using a multi-platform approach is perhaps the biggest talking point amongst transmedia producers and theorists. Because both technical and commercial aspects of transmedia are still evolving, many assume that this mode requires a relatively novel business model. A few days prior to the conference, I jotted down the one or two things I do know about the business models we've used at beActive to fund our productions. As I looked through my presentation notes, I realised that the strategy for monetising transmedial content was the same strategy producers apply to more traditional content.

Simply put, there are still only two ways to earn money from your intellectual property: your audience pays for your content, or you give it away for free and draw your revenue from advertisers. The so-called 'fremium model' requires that a producer makes a portion of content available for free in the interest of marketing, while another portion – the premium content – is sold to bigger fans. In the first instance, the producer runs adverts across his content or embeds product placement advertising within the same.

If this is the case, why do producers and theorists continue to claim that there is no business model for transmedial production (or any form of digital online content)? The confusion arises not from the business model or the inherent risk producers take on when experimenting in digital content, but from the funding model associated with transmedia content. Film and television producers are used to getting funding from broadcasters, networks, film boards and public film bodies, as well as tax credits and advances from distributors. This sort of funding model has become an industry standard and has been the basis for thousands of big and small screen productions throughout several decades.

The notion that transmedia does not have a dedicated business model stems from the fact that there is still no template for funding this type of production. Broadcasters that commission transmedia or on-line projects are still rare, and there are scarcely

any film boards or public funding bodies which offer sponsorship for these kinds of projects. The tax incentives that traditional media broadcasters enjoy do not apply to transmedial or digital projects (with the exception of a few territories like Canada). What's more, the few distributors that do operate in this arena don't typically offer a minimum guarantee on projected sales to producers.

In spite of the fact that personal video recorders and Internet-based devices allow viewers to tailor their own schedules, the industry has been slow to adapt to this shift in paradigm. Ninety per cent of the content created by traditional broadcasters and networks is still linear in format and geared toward television broadcasts; online and digital media are merely supplementary windows through which broadcasters re-run previously televised material. This trend has inhibited transmedia producers and financiers in establishing a consistent funding model. Original web or digital commissions, or web-only licensing deals, are still a rarity even though network websites, VoD services and other forms of on-demand entertainment account for a significant portion of their day-to-day viewership.

Nevertheless, independent producers are able to market, distribute and sell content directly to audiences for the first time in the history of the industry. The Internet, social media tools and mobile devices have made it possible for producers to market a transmedia project locally or globally, as well as generate revenues by selling standard or premium content. Online stores and portals like Graphicly (comic books), SmashWords (ebooks and novels), Apple's App Store and Google Play (mobile applications), Amazon (physical or digital goods), Mopix (film to App services) and Distribber (video on demand) have created a context in which the independent can act as both producer and distributor. He's able to retain control of the manner in which his content is marketed and distributed, as well as maintain higher profit margins.

The Entrepreneurial Approach to Storytelling

To become part of this digital revolution, you'll need to learn new skills in development, marketing and distribution. The multitude of platforms and formats available to you as a transmedia producer can be exhilarating and overwhelming. Throughout the initial phase of a project's development, it's typically prohibitively expensive to create and launch every transmedial element simultaneously.

The first challenge you'll face, therefore, is seeding capital to develop and launch the initial elements of your property. Typically, these projects extend across several platforms, and most financiers will only consider funding a project on a platform-by-platform basis. Even though the transmedial approach is increasingly platform agnostic, the commissioning process continues to be device-orientated. Therefore, cross-media producers must learn how best to utilise a business model specific to their approach.

This is not to say that you need to single-handedly develop a transmedial business model, but you need to be disposed to working within an industry that, by and large, is set up for platform-by-platform funding. Break down your overall transmedia funding model into specific platforms and, when you approach a film funder, only pitch the film element of your project. When you go to a games developer or broadcaster, be sure that the central part of your pitch is your game or series.

While it may be helpful to solicit funding for a project that is based on existing or projected intellectual property (a book or a film, for instance), do not launch into your long-term transmedia plan. At beActive, we've developed a funding strategy which divides our production model into stages specific to platform so that potential funders will know how to respond to our pitch.

We design three to four different pitches for every property we produce, one for each distinct platform. Each pitch highlights that aspect of the overall project, which aligns with the goals and expectations of a particular funder. Think of your transmedial plan as a staircase. To ensure that you don't lose focus during any one of your pitches, break down each element of the 'big picture' into platform-specific steps. That way, you can approach radio and television broadcasters, publishers and games companies with a clear and focused pitch.

Rather than representing ourselves as transmedia producers, we focus our presentation on content created for a funder's go-to platform. If we are pitching to a broadcaster, for example, we frame our presentation with television co-productions we've been involved with in the past, such as the series Living in Your Car and The Line, which we developed in partnership with HBO. Indentify individuals companies and services that can help you grow each particular step of your project. Then pitch each individual element, from a radio broadcast and magazine column to television series and a feature film, according to what each entity can greenlight.

If you pitch all of the elements in your plan simultaneously, you imply that each platform is equally important. As exciting as your overall plan may be, pitching the 'big picture' to a broadcaster, even a major player like NBC, will probably succeed only in making your potential backers uncomfortable. They've never produced anything to the scale you're proposing and are unsure of how to make it work. Rather than trying to seduce them with the full spread of your plan, organise your pitch so that it synchronises with your funders' expectations. Then gain their trust by showing your production credits within their format. Your goal is to demonstrate this one element of your 'big picture' property in the best light that you can.

Even though there is no rigid framework for the standard product-for-finance exchange in transmedia, there is an industry precedence for transmedial funding. Put simply, the transmedial business model is geared to generate direct streams

of revenue from your advertisers and your audience. This is by no means a novel business strategy; it has been the go-to method of traditional broadcasters for years. For independent producers to put this concept into practice, they must learn how to behave like a nanostudio.

Keep in mind that the nanostudio strategy requires a long-term investment. Unlike the finance model, it will not yield immediate cash returns. It will, however, ensure that, in the long term, your projects will work for you by generating sustained, independent profits. Bear in mind that the pioneers of cinema were trying to create a new format that few believed in. When the form was in its infancy, critics did not take it seriously. Cinema was considered a faddish offshoot of vaudeville. One hundred years later, producers are exploring new digital platforms online. Like the Hollywood studio moguls of the twentieth century, the pioneers of new media have the opportunity to bring digital art to the mainstream.

The Perfect Transmedia Pitch

In the most traditional sense, transmedia means business. By employing this approach, you'll be able to retain ownership of your intellectual property and thereby increase your opportunity to monetise on your brand if it is a success. If your brand fails commercially, on the other hand, you must assume the majority, if not all, of the risk. Unlike the conventional 'service provider' business model, the success or failure of your project is almost exclusively in your hands. This may sound daunting, but in my experience no one sells you better than you sell yourself.

Say you have a meeting with a potential financier. Here are some pointers on pitching a transmedial project:

◊ Focus on these two key elements: story/format and audience engagement.

◊ Create a visual mock-up of your project that will captivate prospective investors. Storytelling is a creative process, and your presentation should reflect the most compelling elements of your project in a clear and concise manner.

◊ Be sure to pitch the core story with reference to your target audience. What is your story about?

◊ Pitch your characters. In my opinion, characters are key to transmedia projects because they are the ones who host the experience across different platforms and connect all of the elements. Pinpoint who is guiding you through this experience and how is this person (or group of people) engaging? How will your audience relate to them?

◊ Why do you think people will connect with the story and the experience? Is it funny? Is it entertaining? Is the audience contributing to a cause? Are they rooting for and helping your lead character achieve his/her goal? Is there a prize involved? What's the hook you've created to engage the audience? What do they stand to gain if they enter this transmedia experience and spend their time interacting with your content?

◊ Provide investors with an outline of your multi-platform strategy and your distribution timeline. List the platforms you will use. Put them on a timeline to show where the experience starts and ends and how the audience will move from one platform to another. What comes first? Where is the story moving to?

◊ In addition to listing the features of each of your platforms, e.g. your website, your game, your Facebook page, etc., it's important to give a one-line explanation of why the project requires that platform to engage the audience. Is it to create engagement, build a community, generate revenues, market the experience, etc?

◊ Only pitch what a given sponsor can commission. Only pitch a television show to a broadcaster or a book to a publisher. Pitch what they can buy. In other words, make it as easy for them to say 'yes' without having a second or third meeting with other departments.

◊ Pitch at the right level. Do your research and find out how much funding a particular company or film board can offer. There's no sense pitching something they cannot afford to undertake.

◊ Be sure you have established ownership of your property in the public sphere to avoid potential confusion as to the rights of your IP. Avoid 'checklist transmedia'. Only employ platforms that lend themselves to your project and reinforce its authenticity. Don't feel pressured to use media like Facebook or Twitter simply because it's popular. Remember, any platform that is not an organic extension of your concept can only function as a gimmick or add-on.

◊ A good trick to help potential funders focus on the core strengths of your idea is to create a poster or a digital ad so you can show them how the idea or project will be presented to an audience. Design a search engine banner or a mocked-up Google Ad you could use to promote the project. Think about how you can seduce the target audience with a log line or one-sentence pitch of your project.

◊ As I mentioned earlier, no one can sell you like you can. If you have a project or a product or a character you truly believe in, your passion can be a powerful motivator.

The Practical and Financial Benefits of Transmedia

There are three reasons why small to medium-sized production companies should adopt a transmedial approach. First and foremost, transmedia allows you to retain complete control over your story as well as the ways it's marketed and distributed. Secondly, transmedia allows producers to undertake an alternative production model that involves a minimum investment up front to seed and promote the project in its earliest stages. Thirdly, transmedia can provide independents with new, more sustainable sources of revenues.

Due to the increasing fragmentation of audiences across television stations around the world, traditional broadcasters are being confronted with shrinking budgets and less substantial revenues. In turn, the commissions independent producers used to rely upon are becoming increasingly rare. Now more than ever, the convention of producing television programmes for a broadcaster is an uncertain source of revenue. If independent production companies are to survive, they must be able to generate alternative revenue streams from their products. What's more, broadcasters are spending less and less money on true independent productions and investing instead in the so-called Big Indies – established producers and directors who do not pose as great a financial risk as lesser-known independents.

The transmedia approach addresses the financial difficulties faced by today's independents by providing them a range of digital platforms through which to seed and develop their projects independent of traditional broadcasters and publishers. Audiences are no longer confined to one medium; they're accessing content on a range of nontraditional platforms. If you want to engage them, you need to bring your story to them via the Internet, mobile phone, or tablet applications. This shift in audience behaviour poses a substantial problem to producers entrenched in a more conventional mode of linear broadcasting. Competition for viewer loyalty is no longer limited to what rival television channels air during the same time slot as your show.

In the contemporary world of new media, it's vital to take stock of your competition as the bewildering array of information that is available anywhere, any time, on any device. Your audience is constantly bombarded with all manner of distraction from television shows and web-series, user-generated content on sites like YouTube and Facebook, personal emails and work. By adapting your story to a transmedial output, you'll be able to not only attract an audience's attention, but also sustain their interest and monetise their continued engagement.

What Do Audiences and Advertisers Pay For?

As I mentioned earlier, there are varying degrees of audience engagement, from the casual content browser to the hard-core fan. In order to monetise my content, I need to devise experiences that will prompt casual users to make the jump from engaged viewer

to paying viewer. Of the multitude of content-based experiences you can produce, your audience will typically be willing to pay for:

- live events (ticket sales)
- downloads (music, ebooks, videos)
- apps and mobile games
- console or video games
- premium SMS/calls
- paid video on demand
- merchandise (books, DVDs, toys, etc.)
- crowdfunding or competitions.

You can also monetise your content by forging partnerships with advertisers who will pay for:

- ad breaks
- pre rolls (ads which precede Internet videos)
- sponsorship
- product placement
- ad funding programming.

To secure revenue from viewing communities and sponsors, you'll need to establish traction with an audience by engaging their interests on multiple platforms. Advertisers will be attracted to a project that has already generated a strong fan base. Keep in mind that the data you'll be able to collect when developing your property, e.g. the size of your audience, its demographics, and its behaviours, are invaluable to advertisers. Creating the appropriate audience experience is essential to building a fan base. Before you can monetise your audience by identifying which experiences they're willing to pay for, you'll need to source funding to bring your idea through the incubation and development stages.

First Stage Funding: Development and Incubation

In Chapter One, I discussed three distinct practices associated with transmedia: the brand extension, the web series or 'stepping stone', and organic transmedia. Now I would like to highlight some of the funding opportunities available to producers whose projects fall into these three categories.

Funding The Brand Extension

When transmedia is used as a form of brand extension, its exclusive aim is to increase the brand awareness of a core product like a blockbuster movie or a major

television series. If and when the core product becomes a commercial success, transmedia is used to generate additional revenue with spin-off applications, games, or merchandising. While multiple platforms associated with the primary product may emerge, the film or TV series remains firmly at the centre of the transmedia strategy. The broadcaster, studio, or sales agent covers production, marketing and distribution costs.

Media funds are available in multi-platform schemes and range from $20,000 to $200,000. Many of these organisations encourage producers to co-produce with companies who can offer specialty expertise in areas such as gaming or digital publishing.

There are also regional funds and tax credits to be found in the UK, Germany, and Canada. The Danish Film Institute's site Media Desk Denmark lists sources of funding available in Europe for games and other digital content. Two other reports worth noting are 'Transmedia Financing in Europe' published by Media Desk France and 'Crowdfunding in a Canadian Context' published by Canada Media Fund.

Funding a Digital Property

As I mentioned in Chapter I, the web series or digital-only release is an attractive strategy for smaller production companies. By using a single digital platform, the producer is able to test his content in real time while keeping costs to a minimum. Some successful digitally-originated brands include Angry Birds, Moshi Monsters, Club Penguin, Stardoll, Talking Ben, and The Guild.

In terms of financing the web series, services like Hulu, YouTube, Netflix, Yahoo, and Amazon do provide advances for exclusive content. YouTube, for instance, has given advance revenues to a number of American and European production companies to develop YouTube channels. Advertisers and media agencies are also commissioning content to promote their brands. Even traditional broadcasters are beginning to fund web series exclusively for their own websites to gauge the potential success of a concept for television.

Additional sources of funding for digital content include venture capital or private equity, national and regional game development funds, digital publishers, and crowdfunding.

Funding The Organic Transmedia

Let's say you've developed a strong concept complete with three-dimensional characters and a detailed storyworld. You've fleshed out the types of media you'd like to use, and you're ready to share your vision with the world. The next step is to bring

your production into its finance stage; however, unless you're a major Hollywood studio, you more than likely do not have the financial firepower to single-handedly develop and launch your project on every one of your chosen platforms. In other words, you are going to have to convince investors that you have a hit on your hands.

So what's the next step? Say you put together a slick presentation to present to potential funders, broadcasters and partners to try to get them on board. You book meetings, pitch your concept to dozens of people, and they seem to love it; however, months pass, and no one has signed a cheque. You begin to doubt yourself. Is your idea a good one? Should you change something or abandon it altogether? It's very likely that your misgivings are unfounded and that your transmedial concept is, in fact, a good one, but the entertainment world is full of good concepts. To ensure that your innovation makes an impact, you need to create a product, not just a project.

To do so, you'll need to begin producing elements of your transmedia project yourself to convince other parties to fund it for you. Focus on one or two platforms available to you that best demonstrate how your product works. These initial elements will function as a 'live' doorway into your storyworld.

Launch your project on a medium you are most comfortable with and break out from there. If, for instance, your company is web-based, you should consider focusing your initial release on Internet platforms such as a flashy website or a web series. If your company is television-orientated, you may want to produce a short form episode or pilot to be aired online. If you're more familiar with the publishing world, your starting point could be a novel or perhaps a series of magazine articles. Remember, you shouldn't attempt to produce and publish every element of your project simultaneously; you should, however, plan a timeline, which details how you expect to extend the property into other media.

At this point, you are investing your own time and capital and very likely calling in a few favours. In the long term, advertising investments and audience purchases will generate revenue; in the short term, you'll need to access funding for the all-important development and incubation period in order to launch your first book, game or web series. Unfortunately, there isn't an established business model for transmedial development. At beActive, we use a combination of three funding sources to support the early stages of a project's development.

(i) Venture Capital and Private Equity Investors

Individual entrepreneurs or businesses may be willing to finance your intellectual property. It is important to note that they are not investing in one or two specific platforms, but on the future collateral success of your brand. Be sure to prepare a business plan when pitching to private equity investors. Venture capitalists tend to be more comfortable financing IT and digital-based companies as opposed to film and content producers.

(ii) Research and Development Funds

Traditional audio-visual funds are focused on film and television production. Where, then, is the money in this new digital world? Who's funding the web series, games, apps, ebooks, comics, community management, augmented reality tools and all the flashy new applications available to engage sophisticated audiences? In the past, my team and I have been successful in attracting research and development (R&D) and seed funding from national and European institutions.

As a commercial art, transmedia is still very much in its infancy. Many projects are considered experimental in nature because they do not follow the established language or structure of film and television. R&D funding from the IT and software industry is an excellent source for innovative transmedia producers to procure funding. Private 'Business Angels' can provide crucial start-up capital.

If you decide to pursue funding in this domain, it's imperative that you understand the environment, priorities and, most importantly, the 'language' of R&D agencies. The directors of these bodies do not necessarily understand industry standards, such as the three-act structure or character motivation. Bits, bytes, platforms and deliveries define their realm. To present a successful pitch to an R&D financier, you'll need to rephrase or recast your own business plan in such a way that it engages the agency's own priorities. For example, a series pilot is a 'prototype'; a script is a 'specification document' and marketing is the 'dissemination of results'.

(iii) Digital Funding Initiatives

Now more than ever, traditional media institutions are establishing digital innovation funds for transmedia projects. Some examples include the Canada Media Fund, Experimental Funds, national film boards and telecommunications companies.

Online platforms are also beginning to invest big money in 'commissioning' digital content. YouTube, for one, distributed more than $250 million worth of content (in the form of advances) to a group of producers including several established names in television and film. As other platforms follow suit and more funding opportunities are made available to producers, the market will begin to reflect a more transparent transmedial business model.

Second Stage Funding: Going Mainstream

At the end of the incubation period, or 'first year' funding, you should have a project that's generated a quantifiable audience as well as a 'live' product which potential investors and partners will take seriously. Once you have achieved this

degree of success, you're ready to take your project to the next level and compete in the mainstream. Keep in mind that, as an organisation, you'll need to balance the ways in which you generate income if you want to survive this transition. At beActive, we generate enough income through service provision to cover our expenses and operating costs, while simultaneously creating and managing our own intellectual property.

Once a project has gained traction online, we then seek out funding on a platform-by-platform basis. This may require applying to your national film board for support or to a broadcaster or network. If your project requires expertise in an area not represented by your in-house skill set, I recommend considering a co-production with a complementary company that does have the relevant expertise. When we were developing two recent brands, Beat Girl and Collider, for instance, we partnered with graphic novelists, game designers, mobile apps programmers and established film producers.

Your Audience, Your Currency

Before the advent of digital publishing, a property's success or failure could be passed off on a sales agent or a distributor. If my book or film did not sell well, I could suppose it was not marketed correctly. Nowadays, producers have an alternative. We can either continue to blame someone else for the failure of a property, or we can take control of the way we release the content we produce.

In this new world of digital media, if you own an audience, i.e. you've built a community around your content via social media, you'll have a considerable amount of leverage when you pitch your project to potential sponsors. A loyal audience is literally your currency because (1) they will pay for premium content and (2) advertisers are willing to pay run adverts across that content to reach the audience you've built.

Online distribution platforms like YouTube, Hulu, Facebook, and Vimeo, as well as digital stores like iTunes, Amazon, and apps stores allow producers to reach their clientele on a global scale, but they don't 'commission' content in the same way broadcasters do for television. Transmedia producers cannot, therefore, rely upon advances to finance a project.

Your IP, Your Retirement Package

Developing your intellectual property independently in advance of approaching conventional and new media funding bodies will give you a marked advantage over

your competition, who may come to the table with a project that only exists on paper or Powerpoint. 'Live' examples of your storyworld are much more persuasive in a pitching environmental; they allow financiers to see and interact with your property. They can also see the size of the community you've developed around your concept – how many fans you have on Facebook, for instance, or how many readers subscribe to your blog, read your magazine column, or comment online.

When I was attempting to expand the Sofia's Diary franchise into other territories, I always brought as many visual examples of the product as possible, e.g. video clips, magazines, books – any product that demonstrated a quantifiable fan base. I found these live elements to be the most persuasive in attracting both business and production partners; I wasn't simply pitching an idea, but a product with a proven success rate in the marketplace. Remember, investors don't like taking big risks. They want to invest in successful products.

Transforming your project into a tangible product such as a comic book, web series or blog is also crucial to establish your claim to ownership should the brand attract external investors. If you have the resources, it's vital that you make the first deployment of your property and certify the authorship of your work in the public domain. If you approach potential sponsors with nothing but a great idea, you leave yourself open to a number of dangerous pitfalls. An investor is likely to demand a percentage of ownership in return for capital.

Pitching Transmedia

As of yet, there are virtually no commissioners who specialise in transmedia properties. Public service broadcasters are ideally positioned to commission transmedia; their output includes print, radio, television and Internet platforms, but each of these departments is focused on the demands of its own projects. Private networks likewise tend to have in-house print, radio, and television departments which work independently of one another. It is, therefore, almost impossible to sell and develop a project that involves the entire range of a company's in-house media.

What you will find are broadcasters who will commission you to produce a single platform product and then ask you to devise additional transmedia content at no added cost to themselves. There are also broadcasters who have online departments that commission small projects independently for web-only release in a bid to reach the generation of Millennials who aren't loyal to the television platform. You may also come across companies or brands who will sponsor online series exclusively for online distribution that are not integrated into their mainstream marketing campaign; however, a dedicated transmedial department that can commission a full transmedial project is almost unheard of.

Figure 6. Collider's digital marketing strategy.

Having said that, my company, beActive, was fortunate enough to work with OI Telecom in Brazil to create the cross platform thriller Final Punishment. In my experience, OI represents an exception to the rule. The company had the desire to showcase work across each of the platforms they service – television, radio, Internet, and mobile.

CHAPTER III - Building Your Storyworld

- Characters are Key
- Collider: From Concept to Cross-media Franchise
- Creating an Experience vs. Telling a Story

Characters are Key

In order to build an entertainment brand that can drive sequels, spin-off series and merchandising, focus your preliminary development on three key elements:

• Compelling characters
• An exciting and convincing storyworld
• A strong storyline with clearly defined plot points.

Dynamic, three-dimensional characters have always been a pivotal factor in film and television franchises, no matter the genre. Spin-off products such as toys, apparel, video games and confectionary are almost always character-driven.

Characters are even more important in determining the success of a transmedial franchise. They are the emotional link between your audience and your content. Not only do they introduce us to your storyworld, they authenticate the experience by acting and reacting to that world with all the quirks of human nature. They are, at different moments, vulnerable, loveable, laughable and outrageous. They say and do things we would like to do ourselves, but do not. We wear t-shirts emblazoned with their faces and catchphrases. Why? Because a strong character is the point through which a story transforms, from a passive 'telling' to a deeply personal shared experience. They demonstrate something of our own reality and reveal us to ourselves.

Regardless of the kind of story you're trying to tell, your characters are key because they are what your audience will connect most profoundly with. We are used to engaging and creating relationships with other people. Shows like Sofia's Diary are among our most successful projects because the title character is well-defined and relatable. Fans could imagine her as the proverbial 'girl next door', a schoolmate and friend.

Filmic characters, on the other hand, tend to be subordinate to the overall narrative. Nicolas Winding Refn's film Drive, for example, follows the story of a relatively flat male lead who's listed in the credits simply as the 'Driver'. The character, played by Ryan Gosling, barely speaks. The audience knows almost nothing about him, and yet the overall tone of the film – its pacing, atmospheric soundtrack, and narrative – arc together to make for a great cinematic experience.

While a film can be successful with underdeveloped characters, television series live and die by the strength of their characters. Viewers tune in week after week because they've made a personal connection with a character. They may forgive a poorly written episode or repetitive narrative structuring because they want to see their 'friends' on air. Characters are even more important in transmedia; we're asking people to literally connect with a persona on social media and other digital platforms. These characters act as the MCs of the full transmedial experience. To engage your audience, transmedia characters need to look and sound authentic. They should have a voice and a backstory your audience can relate to so profoundly they'll want to connect with your content, post comments online, 'like' character profiles, and share media.

Where 'strong' characters in film and television tend to be defined by enthralling backstories and singular personalities, strong transmedial characters need to be likeable (or hateable); they need to compel your viewers to engage with them again and again. Your audience will find it very difficult to relate to an abstract idea or a product. Characters, on the other hand, give them a guiding persona to experience your storyworld, however fantastic.

In my opinion, the success of the Angry Birds franchise has more to do with the likeability of the little birds than it does with the game itself. All of the merchandise and mainstream media that came on after the game went viral is based on these characters. Despite the fact that they are 'thin' characters, who do not reveal distinct personalities or backstories, the birds are so loveable people want to engage with them by slapping an Angry Birds cover on their iPhones or wearing an Angry Birds t-shirt.

A persona, even one as simple as Novio's birds, is more likeable and therefore more engaging than any abstract idea. Almost every top kids' shows – from Peppa Pig to The Witches of Waverly Place – is based on a strong central character. Whether you're creating an animated or a live action project, keep in mind that your main character is the face of your show, the person who your fans will sympathise with and follow using social media.

In the run-up to our launch of the Collider feature, we split our international Facebook fan page into localised Portuguese fan pages, using each of the story's six characters as hosts of page-specific content. User traffic has increased dramatically because our fans now have someone they can relate to speaking to them directly. Each character makes his or her own posts, addressing the audience in the first person – a much more affective persona than 'beActive'.

To promote the movie online, we hired an actor to portray one of the film's main characters, Carlos. He addressed the audience directly in a short clip with a call to action: 'The world needs to know about Collider! Can you help me get the word

out?' There are two advantages to adopting this sort of crowd-sourcing technique: it allows us to promote the film cost-effectively, and it establishes a deeper connection with our audience. Of course, they realise that the man in the clip is in character, communicating with them as a representative of the film; however, by giving them a face to connect with, as opposed to running a more traditional advert, it compels them to become a part of the Collider universe by clicking on a link or downloading content, or telling a friend about the film.

If you're shooting a live action series or film, it's vital that you find the right actor who can bring to life your character's personality from their boldest to their most subtle traits. Underline whatever there is about your characters that one can love or hate to draw the audience into the story and incite them to interact with the characters' online personas.

When we remade Sofia's Diary in the UK, for instance, we partnered with Bebo, a social media network aimed at teenagers, and created profiles for each of the main characters. The actress who played Sofia's nemesis, Rebecca, was bombarded with hate mail. She came to me in tears. 'They all hate me,' she said. Once your fans start to take sides, you know your story has made a meaningful impact. I explained to the actress that every one of those 'negative' comments was an affirmation that the audience loved her work. She had created a conflict so real, so emotive, that the viewers had flocked to her Bebo page to tell her just what they thought of her character.

Like Sofia and Rebecca, your characters need to be strong enough to initiate and maintain a conversation with your target audience. If you are writing for a serialised format like a web or television series, you need to take particular care in developing larger than life characters. Audiences tune in to a show to engage with a familiar character more so than narrative, hence the enduring popularity of shows like CSI and Law and Order whose narrative format is always the same. Given strong characters like Horatio Caine and Lennie Briscoe, viewers are willing to forgive a lack of structural surprise and the occasional plot weakness.

If you transpose these characters to a transmedial world via social media and other online platforms, a character becomes even more important to the success of your brand. New media formats are more immediate and social than traditional formats; they provide a space where viewers can interact with content and one another by sharing comments, linking content to their profiles, or creating fan-fiction. Online, your viewers can engage with their favourite characters on demand for long stretches of time, as opposed to once a week for a half hour or hour. Your characters must be vital enough to drive your fans' ongoing engagement. You should create a persona that compels people to talk about your brand, develop intriguing backstories they can discover, devise loveable (or hateable) personalities they can react to and sympathise with, and cast actors and actresses they can relate to.

Building an Exciting and Convincing Storyworld

To ensure that your project will support integrative narratives across multiple platforms, it is essential that you develop a storyworld which describes your fictive universe as it appears before, during, and after the resolution of your core narrative. A fully-fleshed storyworld 'bible' should include:

- Detailed character profiles
- Character backstories and extended story arcs
- Historical and real world events which help define and authenticate your setting
- The rules of your storyworld (if they differ from the rules of the real world)
- Visual elements that distinguish or define your world.

When developing a premise, logo or central character for your brand, keep in mind the generic realm of the piece. Who are the core followers? What other audiences might connect with the concept? At beActive, we examine the marketability of a project from day one by determining whether or not there is a community already built around our story's subject. We try to tap into that community by asking ourselves what sort of entertainment experiences this particular audience is looking for. Collider's niche audience, for example, is familiar with the precepts of science fiction. They're willing to suspend their disbelief in order to engage in the post-apocalyptic storyworld. We decided to develop a graphic novel, comic book series, and a gaming element to draw out the interests of the fandom.

No matter what genre you're writing into, establishing firm rules for your storyworld and sticking to them is vital to creating and maintaining the credibility of your story. Where and when is your story set? Does it follow the rules of today's laws of nature and society, or is there an alternate set of parameters that define your world?

For instance, the Collider feature is set in the year 2018 – the apex of a worldwide catastrophe. The planet is beset with natural disasters, and humankind is on the brink of extermination at the hands of monstrous creatures called 'the Unknown'. The 'rules' of these monsters are evocative of vampire and zombie mythology: they can only attack in darkness. By applying an existing archetype to the Collider storyworld, we were able to create a more complex sci-fi narrative which involves theoretical physics and time travel. In instances such as this, you can draw from your audience's store of generic characters or scenarios to do some of the work of defining the rules of your storyworld. When you are presenting a novel concept, you cannot make any assumptions about what will be transparent to your audience. Be clear and definitive when setting up the rules of your storyworld, and stick to them when you transition from platform to platform.

Think of the rules of your storyworld as the foundations for your 'big picture' property. These rules (and your storyworld 'bible') don't merely lay the groundwork for

your feature film, but also scores of different storylines and plot points that will help you grow the project across multiple platforms.

We developed detailed backstories for each of the six characters in the Collider project, which allowed us to create a series of comic books and a graphic novel to illustrate the independent plot lines of each character's life and the subplots created by their collision in a Geneva hotel room in the year 2018. The Collider feature film reiterates the story's overarching drama – Dr Peter Ansay's sabotage of the CERN Collider and his subsequent catapult through the resulting wormhole – and further develops the implications of his time travel by positing him and five strangers as the potential saviours of the known world.

Figure 7. Collider's experience on multiple platforms.

At present, we're developing a spin-off television series which carries the storyline beyond Ansay's and his begrudging cohorts' success in restoring the collider (and the planet) to order. Now they have control over a time travel device, and they decide to form a Mission Impossible type squad to avoid future catastrophe. Governmental agencies and private citizens hire Ansay and his team to travel into the future, witness a probable crime, and bring back the information necessary to prevent a pandemic from breaking out or a president from being assassinated.

The series complements the overall property and also functions as a standalone piece; we were able to bring off this fifth reimagining of the brand because we took the time, in the earliest stages of the project's development, to create well-defined

characters with in-depth backstories and a compelling storyworld to trot out their real time stories. Backstory is particular important to the Collider project because each of the main characters has the ability to go back in time and relive his personal history from 2012 to 2018. For each of these characters, backstory has a more immediate impact because they have a standing opportunity to not only anticipate and thwart crime, but also the transgressions made in their own lives. By allowing for extensive pre-planning, which provides a logical and aesthetical framework, we will be able to create several seasons of spin-off material.

Building a Strong Storyline

As you plot your project's storyline, reconsider the characters you've developed in your transmedia 'bible'. Look at their backstories. What motivates them? What sort of goals drive their actions? Strong characters have a clear goal; to achieve that goal, they have to move from their starting point 'A' to 'B' and so on. By introducing additional characters to your baseline plot, you can create plot points – moments of high drama, where the desires and the actions of your characters intersect. They may be in conflict with one another and so move to put obstacles in one another's way. They may align to help one another toward a common goal.

Populate the storyworld you're creating with strong characters who have equally strong motivations. Set them in motion toward their defining goal, and you have your baseline plots. Bring them together to create plot points. The Collider storyworld encompasses the lives of six strangers, each with his or her own backstory. Their stories do not intersect until 2018, when they're mysteriously transported to a hotel in Switzerland. When their paths cross, personalities and desires begin to jar one against the other, and interpersonal dramas begin to explode.

Plot and storyline are paramount in providing the basis for brand-based products. Each of your characters should have his or her own strengths and weaknesses as well as goals. They create that all-important relationship between audience and content and drive the full transmedial experience; but it's the conflicts that play out between characters, their alliances and antagonisms, that establish storylines and plot, which can be translated into products.

When Collider's hero Peter Ansay makes a grim discovery, for instance, he is compelled to get the word out, to journey from point A to point B in the hope of saving the world. As his goals come up against those of the other five characters, storylines emerge which we then used to generate comic books, games and the film. Only when your characters start interacting with one another do you have a plot, and when you have a plot you have the means to create products.

8 episode Webseries (+TV Special)

6 Comic Books (1 per character)

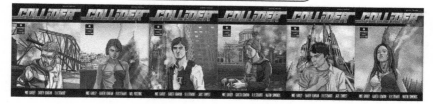

3 Videogames

1 Graphic Novel

1 Movie

Figure 8. Collider's different content offers.

Collider: From Concept to Transmedia Franchise

In 2009, I began sketching a short story inspired by experiments at the CERN Large Hadron Collider in Switzerland. The story follows six strangers who are mysteriously transported to a post-apocalyptic future. Each of them is faced with the same terrifying decision: should they risk travelling back in time to change the future, or take their chances against a band of hellish, wormhole-diving aliens? Their plight begs the question: What would you do if you knew the future fate of the world?

I acted as the project's story architect or showrunner. First, I developed the storyworld 'bible' to nail down the rules defining the Collider universe. I then designated the platforms which would best suit each element of the storyline and distributed the 'bible' to my creative team. The following year, we brought a sci-fi novelist, screenwriter and graphic novelist on board to improve upon the storyline.

By the first quarter of 2011, we hired a game designer to develop two games which would integrate with different elements of the Collider storyworld. That summer, we began developing the fourth draft of the feature film, which required the adaptation of several plot points and character profiles. As always, we allowed the Collider concept to evolve throughout its development by incorporating audience and industry feedback.

In the fall, we commissioned a second comic writer and a team of illustrators to produce six digital comics. Each comic is divided into two parts; the first immerses the reader in the day-to-day dramas of each of the six character's lives before they're transported to the future, while the second reveals what happens to each of them in the future.

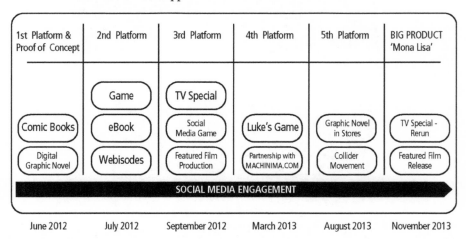

1st Platform & Proof of Concept	2nd Platform	3rd Platform	4th Platform	5th Platform	BIG PRODUCT 'Mona Lisa'
	Game	TV Special			
Comic Books	eBook	Social Media Game	Luke's Game	Graphic Novel in Stores	TV Special - Rerun
Digital Graphic Novel	Webisodes	Featured Film Production	Partnership with MACHINIMA.COM	Collider Movement	Featured Film Release
SOCIAL MEDIA ENGAGEMENT					
June 2012	July 2012	September 2012	March 2013	August 2013	November 2013

Figure 9. Collider's distribution timeline.

At the end of the year, we began work on the first mobile game inspired by the film. By January 2012, we'd begun shooting an eight-part web series which featured the story's

central protagonist, Peter Ansay. The series sets up and delivers the inciting incident of the overarching storyworld. We also created six motion comics – one for each of the main characters – to accompany the prequel on our YouTube channel.

In March, we secured the funding to produce the Collider feature film and, in mid-May, we teamed up with longtime partner Wattpad.com to release Peter Ansay's 'Log' while plugging the franchise at the Kapow! Comic Convention in London. On 4 June 2012, we released the first pieces of digital content online including the web series, the comics, and the mobile game Collider Quest. We also released an enhanced ebook version of the story on Wattpad.

That summer, we released the collector's edition of the graphic novel and presented the piece at ComicCon 2012 in San Diego. In October, we began shooting the digital feature film and released the second Collider inspired comic book series in October. The feature film was then released in European theatres and on VoD in the fall of 2013.

As with past productions, we dedicated the first two to three years' work on Collider to marketing and promotion. We built a fan base by giving away certain pieces of content including the web series and motion comics. We then adopted a 'freemium' model to further engage our audience, offering the first of the six digital comics for free at Apple's App Store, Google Play as well as our Facebook fan page. Likewise, viewers could download the first three levels of the Collider Quest game free of charge; the final eleven levels are paid premium content.

beActive's Production Model

1. Designate a story architect or showrunner to:

• Create a concept and write initial copy (treatments, short stories, synopses, etc.)
• Develop the story's main and supporting characters
• Plan a production timeline
• Nail down plot points.

The showrunner/producer oversees every element of the project from its conception to its cross-media launch. He or she supervises the production of each piece of content to ensure that the brand maintains both integrity and consistency across each platform.

2. Develop a storyworld 'bible' for the property.

Think of the 'bible' as the manual or cookbook for your transmedia project that will help you and your team understand the look and feel of the storyworld as a whole. The 'bible' should include a sketch of the core storyline, character profiles, plot points and essential visual elements. You can use this information to gauge your property's market potential, produce promotional materials and create a more effective distribution plan.

3. Hire specialised talent to produce textual content and script which can be applied to different platforms (the web, television, mobile games, etc.).

Look closely at each element of your story universe. Determine which media best suit the kind of story you're trying to tell, keeping in mind that each product should be self-contained and function independently of the collective multi-platform experience. Each platform extension should add something to the story – a visual richness or a unique perspective – despite unavoidable narrative overlap.

Be sure that each product conforms not only to the rules of your storyworld, but also those of your chosen platform and the experiences audiences expect from them. Very likely, you will not be pitching your product to one audience but to several, each with its own likes, dislikes and expectations.

The biggest challenge we face when expanding a property is maintaining story and character integrity across each new platform. In an attempt to cash in on the success of Sofia's Diary, we began to publish books written from the point of view of Sofia's younger sister, Mariana. Each of Sofia's 'diaries' represented a particular moment in her life; Mariana's diaries retold the story from her own point of view. The girls' diaries were produced by different teams, so there were various instances when certain details didn't match up. When they were published side by side, our audience caught every one of these inconsistencies, and we were flooded with emails. This and other similar experiences reminded me just how important it is for producers to make consistency and their viewers' experience their number one priority.

Creating an Experience vs. Telling a Story

Perhaps the biggest misconception in the entertainment industry is that people buy content when, in fact, we buy experiences. We buy context. The real value of content is not so much a function of the product itself, but what it means to us and how it mirrors the self back and makes our own lives seem infused with meaning.

In the past, content always came in products, e.g. on vinyl, VHS, compact or digital video discs, and had very defined user experiences. At the outset of the digital age there was no longer a need for a physical product; people could exchange digitised content at incredible speed online. Record labels and publishers began to panic. They blamed Internet piracy for a waning market, but in truth they had misunderstood the real value of content.

Consumers did not turn pirate with the advent of the Internet. They've continued to do what they've always done: acquire and share content. But now, instead of recording songs from the radio and compiling a mixed tape or burning an album onto a compact disc, they were uploading and downloading reams of content rapid fire on the web.

Digital sharing portals like Napster and Limewire have made it possible for people to share content faster and on a much larger scale than ever before.

When music piracy spiked in 2001 and 2002, the singles market was still driven by teens. The music industry went crazy. They were offering a high-quality product with two to three songs for roughly €1.99; however, instead of purchasing the CD single, kids were downloading the songs for free. What's more, they were paying €2.99 for low-quality, monotonic snippets of their favourite songs to use as mobile ringtones.

I began to realise that their purchases weren't motivated by content, but by the experience a particular version (or, in this case, reversioning) of content can provide. Having that ten-second, stripped-down version of a pop melody meant more to them than having the CD at home. If they want to listen to the original song, they can find a way to do so anytime, anywhere; but if they want the ringtone, they have to purchase it in a particular format to match their mobile phone model.

Value is not inherent to ownership; the consumer will always find a way to obtain content for free. The real value of any entertainment property lies in its capacity to relay a personal meaning to each one of us. We download apps today for the same reasons teens downloaded those first ringtones more than a decade ago: to personalise our mobile experience and to feel that we're part of an 'in' peer group. Similarly, when we go to see a movie, we aren't going simply to view the film. We go 'see' a movie because we want the experience of context the theatre provides. The screen is bigger. The sound is sharper. Comedy and drama are that much richer when we're laughing or crying along with one hundred other people, and once we've seen the film it becomes the subject of discussion between ourselves and our peers. Stories have always been and always will be a socially inclusive art form. To create a successful transmedia franchise, it is crucial to prioritise the story of the brand and those elements of the narrative which draw people together and spur further discourse between them.

Having said that, we cannot, as an industry, believe that every piece of content we create will find an audience willing to pay for it. Our commercial approach, therefore, does not involve the unrealistic aim of monetising the entire scope of our transmedial output.

In the spring of 2013, we ventured into the world of Chick Lit with the romantic comedy Made with Love. Once more, we teamed up with Wattpad.com to launch a digital version of the novel online. In just three months, two million people had connected to and read the story. Despite the fact that we made the entire novel available online for free, the book retains its value for future publication in print. Of course, not every one of your online readers will be motivated to buy your novel's paperback edition; certain formats are more effective at engaging certain demographics. In general, those consumers who make a personal connect with your content will be most willing to make the move from one format or platform to another, even if they're familiar with the storyline.

I used the same approach ten years ago to seed the Sofia's Diary franchise. Initially, our publisher was wary because the first book in the series was already available online in the form of a daily blog. The publisher thought it unlikely our fans would buy the book because they already knew the story. They agreed to run the first print despite their misgivings. When our fan base learned that the stories they'd been reading online were now available as a book, they went crazy. We sold out of three consecutive printings within the first week of sale and shot into the top five best-selling books in Portugal.

For me, these early buyers of the book were people who already knew Sofia's story; they had already read the book online, and somehow the experience of now owning the hardcopy they could share with a sister or a friend created the right context. They rushed out to the bookstore and bought the book. For whatever reason, translating even a well-known story into a tangible product makes for a richer experience. We all have that friend whose living room is filled with director's edition DVDs or figurines of comic and action heroes. He's familiar with each of the stories; very likely, he's seen each film more than once. For him, however, part of the real value of the story is collecting and owning memorabilia he can display to his peers.

The same applies to our latest project, Made with Love. One reader might connect with its characters, another with a plot point that resonates with their own experiences in the past or present. These are the individuals who are most likely to purchase the novel in hardcopy because they want to read it again in a different medium, or share their experience by passing it along to their best friend or niece. Even if they don't buy the paperback, they may very well be the first queuing up at the box office to see the film.

To be a successful transmedia producer, you need to consider everything you produce, every piece of content that is a part of your big story, and decide which of these has a commercial value. Do not make the mistake of expecting your audience to purchase everything you produce. It may seem counterintuitive, but the best way to create an audience motivated to buy your product is to give them the bulk of that product for free. This method incentivises people to engage with your story, to talk about and share it. Later, you'll be able to convert someone who liked the story into a buyer who will purchase a movie ticket or paperback novel, not for the content itself, but for the experience.

As an industry, we need to stop thinking that everything we produce has a value that we should charge our audience for. I believe that we should give away as much content as possible in order to create an engaging experience. By creating this sort of emotive link with our audience, we can establish a property's real value and motivate our viewers to pay for our products and the premium entertainment experiences we provide.

Not all your fans are equal

While producing the Emmy-nominated Collider franchise, our goal was one which we apply to all of our transmedial productions: to achieve the right balance of interactivity. This involves simple voting forums, which allow the audience to dictate the direction the story takes, to complex alternate reality games that prompt the audience to jump from back and forth from multiple platforms and media.

Say we produce five hundred pieces of content for a single property; we always make the majority of that content – typically three quarters – available for free. We began telling the story of Collider by posting character blogs, ebooks and comics, webisodes and social media fan pages. Of course, the more complex the interactive elements of your story and the more time they demand of your audience, the fewer individuals who will participate in the full range of interactive experiences.

We always design three different types of experiences which reward the specific desires of each kind of audience:

1. **The Watcher:** tunes in for the entertainment value of the story
2. **The Engager:** tunes in to be a part of something relevant
3. **The Participant:** tunes in to become involved, have their voice heard, and/or be recognised by their peers.

There is no formula for creating a transmedia product that strikes the perfect balance between passive and active viewing. Rather than trying to create a standard for the kind of cross-media brands beActive produces, we create several layers of media and adapt the complexity of the experience to each type of audience we're trying to reach. For a sci-fi series like Collider, which is aimed at a primarily male audience between the ages of 15 and 25, we need to create a game-like interactive experience for a percentage of the audience that wants a deeper experience. On the other hand, if we are creating content for a comedy or romance along the lines of Beat Girl, which is based upon a story of sharing and emotion, the level of interactivity and participation we solicit from the audience is limited to more direct approaches such as push notifications and comment threads.

Let Your Audience Be Your Guide

Even though there are broad strokes components that you can point to describe successful transmedia properties, there is no definitive formula of, say, three parts narrative divided by three digital platforms and multiplied by two parts social media, that will yield a guaranteed success. What works for a particular project or audience may not work for another.

A few years after the initial success of Sofia's Diary, we thought we'd cracked the code to producing multi-platform entertainment, so we went ahead and applied the formula we'd used to develop and market Sofia to different concepts intended for different target groups. We created a project similar in format to Sofia's Diary called Looking for Miguel, which featured an older male character. We also developed a concept for an interactive fantasy adventure called Dark Siege. Both projects failed to attract an audience. Their foundering made it clear to us that different target groups respond in different ways to characters, plot points, and interactivity; a one-formula-fits-all was never going to work.

Even though Looking for Miguel and Dark Siege both failed to reach their targets, we more than recovered our financial loss by learning invaluable lessons about our trade. Interactive entertainment and the ways in which audiences react to it will change from project to project and from target group to target group. Moreover, the Internet changes daily; new digital platforms emerge and established platforms fade out. Remember Bebo and MySpace?

The failure of Looking for Miguel and Dark Siege led us to a new formula: there is no formula. There is no winning format producers can simply plug content into when developing multi-platform and interactive media. We need to study each of our target audiences and find out what makes them engage with certain kinds of content; what makes them 'click' on a particular site, follow a particular comment thread? It's crucial that we tailor each property to the preferences and expectations of its target audience. By shifting our focus from a general to a project-based transmedial formula, we're been able to build and sustain audiences for a range of properties, including our teen soaps Beat Girl and Flatmates and our award-winning thriller Final Punishment.

A New Language is Born

As the habits of audiences continue to evolve from traditional to digital platforms like the Internet, tablets and smartphones, content producers also need to commit their resources to understanding these platforms and the ways in which audiences engage with content through them. To better serve our audiences, we producers need to evolve the language of 'new media' which is, in many ways, the conjunction of every medium.

This change is different from those which followed from the advent of cinema, television and the Internet. The medium of new media is not specific, like film was before the invention of the TV, to the platform itself. Today, multiplatform media are defined rather by audience behaviours. Previously, television dramas were written to a strict format; they were sixty minutes long with cliffhangers built in to proceed ad breaks every eleven minutes. Today, people tend not to watch live broadcasts of these shows. They record them digitally or watch them on their iPads. It doesn't make sense

to adhere to the language of television when the needs of most viewers have little to nothing to do with the linear broadcast.

This is not to say that the language of television should be scrapped entirely; indeed, much of the content produced for multiplatform productions still mimes the templates of TV. But the producers of the digital age are no longer constricted by ad breaks or broadcaster's schedules. Viewers can watch three episodes in a row without one ad break using on demand devices or series DVDs. To serve as well as anticipate the needs of our audiences, we need to pay attention to these new behaviours and evolve the language of the medium along with the way we tell stories.

Historically, new media has always borrowed a compositional language from established media; radio and cinema borrowed extensively from the stage, while television drew its formatting from news reels and serialised pre-rolls. As a new medium matures and conquers audiences, it tends to develop a completely novel language specific to its format.

Webisodes and mobile digital content still borrow most of their structure from television. Most of the time, the content that's consumed on these platforms are, in fact, repurposed TV shows that are broadcast in their original formats or chopped into shorter segments; however, as audiences become increasingly sophisticated, more and more producers are realising that repurposing content for the web is not the correct approach. Now we're seeing major TV shows, films, and video games launching spin-off web series, mobile or companion tablet games, digital comic books and ebooks.

Most of these 'extensions' are geared toward monetising the popularity of a TV show or movie brand on new platforms by generating additional revenues through the sale of digital downloads and apps to an extant fan base. This approach can also be used to develop a brand's marketing and storytelling elements. Creators and writers can expand stories and characters to new platforms, extend plot lines and develop backstory without being confined to conventional arcs, formats or running times of conventional television and film productions.

In the past two centuries, storytelling has suffered from the rigidity of established formats. Now, however, with the availability of new digital platforms, creators can regain the freedom to focus more on story and character development and less on segment length, ad breaks, cliffhangers and all of the other tricks implemented to make TV storytelling serve the purposes of media agencies and advertisers.

Even certain types of transmedia, particularly the brand extension, are hampered by their dedication to a central format. Hollywood's strategy involves acquiring the best content available, whether it's a film script, television script or book, and developing cross-media content to extend the success of that central platform. The problems with this model are the limitations imposed by the format of the central platform. The feature

film, for instance, is a highly condensed format. There isn't much room for backstory or internal dialogue; the bulk of your material must play on screen in the space of ninety to one hundred and twenty minutes.

The television series is another very rigid format. In the US, sixty-minute dramas are broken into six parts, with ad breaks every ten to eleven minutes, and thirty-minute sitcoms are divided into four parts with ad breaks every eight minutes. Books are a much more liberated form. With prose, you are free to interpose plot with detail and lapse into moments of introspection.

When you situate the story of a film or a television series as the central element of your project, you will be limiting your script. In other words, if you don't have a world beyond a ninety-page feature script and you'd like to employ a transmedial model, when you attempt to create a comic or an app or a prequel you'll be repeating the same story over and over again. You need to have more stories than your central script so that each element is self-contained and adds something unique to the story.

For this reason, some studios will hire writers after they have achieved success with a film in order to create a transmedial world. These writers create multi-platform content so that, when the studio expands to digital platforms, they have additional plot lines and characters to work with. Our approach, on the other hand, is to situate the story at the centre of our production model. We try not to write content for specific formats; we write the story for the story, define its core elements, and develop different streams of content which are organic to the narrative.

At beActive, we tend to use a more organic approach. By embracing new platforms available to us as well as the social media phenomenon and placing priority on story, not technology, our writers/creators can tell better stories capable of engaging audiences throughout the day. In 2013, we premiered the feature film Beat Girl in Ireland, the UK, Portugal and the US – the final element of this multi-platform series. However, it all started in the summer of 2012, when we released a web series prequel, which was followed by an ebook, paperback and graphic novels, a series of articles in DJ magazines and a mobile game. We supplemented each of these elements by developing a strong social media presence.

Most of the above content would not have conformed to the rigid format of a half-hour TV comedy-drama, but it's proven ideal for both the digital platforms and offline media we chose in order to illuminate Heather's story. These alternative formats are also crucial in building a fan base that is more intimately connected with your characters, their motivations and the series' plot lines. Even though transmedia requires writer-creators to do more work to produce additional content, it affords them with the creative freedom to tell the stories they want to tell.

CHAPTER IV - Planning Your Release

- Pick the Right Platforms
- Pinpointing Your Project's 'Mona Lisa'
- The Storycaster

Pick the Right Platforms

Once you have blocked out your storyworld and developed your central characters and plot line, you'll need to decide which platforms best utilise each element of your property.

Be careful to avoid a checklist approach. Producers who are new to transmedia can make the mistake of creating content for every available platform. They set up Facebook and Twitter accounts, launch online series and mobile apps without asking themselves if these particular platforms make sense for their product.

To get the most out of your adaptation of the transmedial approach, be sure to examine which platform (or platforms) best suits the tone and intent of individual pieces of content. Traditional print novels and ebooks, for instance, introduce your audience to the inner voice of your main character or characters. They invite the reader to engage in imaginative play. A book is also a medium which allows for more descriptive asides that add both texture and depth to your storyworld. What's more, when your fans are reading your book, they're not doing anything else. You have their full concentration.

Keep in mind that not all stories or transmedia formats can output good books, whether you're considering a traditional novel or graphic novel. Likewise, not every book can be successfully translated into a transmedia property. Writing and publishing a book associated with transmedia property can't be an afterthought – it is just one more element in a long list of media the producer wants to use to extend his or her property. With so many novels on the market, your book needs, first and foremost, to stand out as a result of its own merits. Take pains to ensure that the writing is of a very high standard and that the product itself is high quality, with eye-catching cover art and stirring synopses.

Ebooks are rapidly becoming the preferred format of younger readers. Since we licensed Sofia's Diary in 2003, the industry has experienced a huge increase in ebook penetration among teens and young adults. More and more, they're using digital devices to experience books in a digitised format. In addition to 'formal' ebooks that can be accessed using a tablet or an ebook reader, younger audiences are also increasing their usage of online e-reading services like Wattpad.com and Movellas.com. These are online communities that host professional and user-generated content to provide ebook-like experiences to their users. Readers can access their favourite stories chapter by chapter and browse content organised by genre and popularity. Both sites offer community building tools that prompt audiences to comment on content, share stories with their friends and peers, and participate in the storytelling process by generating fan fiction.

To date, we have released three books on the Wattpad.com platform with tremendous results. The new Beat Girl series has reached more than 800,000 readers, while the two novels Aisling's Diary and Made with Love have reached more than 2.5 million readers. Why are readers drawn, by the tens of thousands, to the digital format? We believe that digital platforms allow for a more immediate reading experience than traditional books. The stories evolve with the audience. They're given the chance to comment on the characters and plot lines, to suggest new ideas, and even have their participation reflected in the upcoming chapter and the final version of the ebook. We then complement each ebook with audio-visual content available in short-form format videos, as well as content designed for other platforms including casual video games for smartphones and tablets. Our strategy is to establish the same type of relationship we have with our ebook fans in other media and formats.

Our goal is to create new stories in partnership with our audience. By allowing our readers to be part of the storytelling process, we're able to grow a more committed fan base, create better, more relevant stories, and publish both traditional books and ebooks in higher volume based on the developmental work we do with our fans. The ebook format along with services like Wattpad.com and Movellas.com allow us to bring stories to audiences faster while giving us the means to listen and interact with our audience in real time, something that is much more difficult to achieve with a formal paperback book. If you are developing a story that would translate well to a book format, especially one geared toward a younger target audience, try to adapt your development strategy to fit their needs and preferences.

As versatile as the book format is, sometimes you need to create situations and events that make the story you want to tell more relevant. This is why we utilise the short-form experience on digital platforms to create characters that are likable and authentic. If the audience can see them, even if it's just a photo or a post or a short video that the character publishes daily or weekly, he or she becomes familiar to them. The audience can better relate to them because they're a part of their daily lives. Like their own friends, they see them in different contexts every day.

Graphic novels add a visual element to your storyworld. Character-driven television or web series are perfect platforms for dramatic and comic interaction. Live events such as stage plays, stand-up comedy, and role-playing games engage the audience in the 'real' world. Radio plays, sketches, and chat shows are best suited to light and comedic content, while the visually-driven feature film authenticates your story by bringing it to life.

Take into consideration the kind of experience each platform lends itself to. What time of day and in what sort of context will your audience have access to each piece of your content? Which elements invite them to lean back and experience your story passively and which prompt them to lean forward and interact? At the end of the day, a good story will be told in the lean back format. Of the lean back platforms, cinema

is the ultimate medium. The audience is seated. They've switched off their phones. It's dark. The surround sound is drumming away. To my mind, there's no better way to tell a story; you have one hundred per cent of your audience's attention (unless your movie is boring and they fall asleep).

Television is not as ideal a format as cinema – there are ad breaks and people wandering in and out of the room – but it's still a powerful tool as it engages your audience's emotions by delving into plot and character through image and sound. It's particularly suited for serialised content divided into thirty to sixty-minute segments.

Social media as well as other digital platforms provide you with a forum to involve your audience in the day-to-day happenings of your characters' lives. These platforms create a notion that there is something ongoing and exciting about your story. We use this sort of lean forward experience to create an intimacy between our audience and our characters that exists in real time. Digital and social media applications allow us to make many small connections and intersections with the viewer's life and the storyline, which enrich the experience with detail and an ongoing sense of immediacy and intimacy.

If music is integral to your plot line or your characters, you may choose to create or release a soundtrack on iTunes or Spotify. Is your story based on a quest or battle? Even casual games invite the audience to imagine themselves as your hero (or villain). Does it make sense for you to project your viewers into your characters' point of view? Which ones? If you're considering designing a mobile app, ask yourself whether or not it will enable the audience to better understand and connect with a character or an element of your story universe.

Pinpointing Your Project's 'Mona Lisa'

When you're developing content specific to best-fit platforms, keep in mind that the success of these products will depend upon their capability to reveal some aspect of your story's heart.

Think of your storyworld as the Louvre and the heart of your story as da Vinci's Mona Lisa. Eighty per cent of the people who visit the Louvre are only there to see the Mona Lisa. They make their way to the corridor where the portrait is housed, stand in front of it for a minute or two, wander into a couple of adjacent corridors, get tired and then go home. There are so many galleries in the museum, but the majority focus their viewing experience on the Mona Lisa.

As a transmedia producer, you need to consider what that core element of your story universe is that has the figurative drawing power of a masterpiece. Focus your resources and your creative energy on your Mona Lisa and the 'corridors' leading to it and from

it. Roughly seventy-five per cent of your capital should be spent on your masterpiece. If you have the time and the money, you can redirect your attention to developing products that flesh out other less critical elements of your storyworld.

The Storycaster

Timing and efficiency are critical to transmedia, so you'll want to develop a distribution plan which streamlines when you release each piece of your content. At beActive, we adapted our distribution strategy into a digital scheduling and distribution platform called the Storycaster, a tool which eases the tasks of making content available on YouTube, Facebook, Twitter and other social media networks on the web, mobile, tablet and connected TV devices.

In 2009, we released our transmedia property, Final Punishment (Castigo Final), an interactive thriller comprising of more than one thousand pieces of content, in just sixty days. In order to release this volume of content efficiently across multiple platforms, we organised content writers and creators, marked out a delivery schedule, and managed the day-to-day launch of specific pieces of content from image streams and texts to

Figure 10. The Storycaster concept.

blogs and web series. At the time, we had to coordinate our distribution plan manually. We had team members up at four in the morning to ensure that a particular piece of content went online at 4 am. Of course, this sort of 'by hand' distribution is not manageable in the long term, especially when your creative team is juggling a high volume of content between time zones and continents.

The difficulties we had in managing the Final Punishment project inspired us to design a remote tool that is story-centric. We needed a distribution programme better suited to the types of stories we tell, one geared toward our multi-platform method and a publishing schedule that engages several social networks at the same time. The Storycaster allows producers to assemble large-scale projects to be distributed over a given period of time, whether one month, two months, or a year, which include hundreds of pieces of content. We are in the process of licensing this technology for the benefit of other transmedia producers.

By using the Storycaster, you'll be able to create a hybrid distribution plan in which you give some content away for free to promote your brand and receive revenues by way of digital advertising. The goal of the service is to enable you to build a fan base around your property and then promote the sale of companion products, e.g. digital downloads, books, ebooks, games, apps, music CDs, DVDs and other licensed products.

The service is aimed at producers and production companies, studios, broadcasters, and publishers to take advantage of the digital market without any requisite know-how regarding platform creation or maintenance. By using the Storycaster, you can embrace new digital and mobile platforms and create more engaging experiences for your audience, as well as benefit from new marketing opportunities by monetising your content on different platforms.

Increasingly, audiences are engaging with content on multiple platforms. They expect their favourite stories to be available on every one of their go-to devices, but the ever-changing technology that makes this sort of on demand storytelling possible can be daunting. Storytellers want to focus on producing the best content possible rather than learning how to use new technologies. The end-goal of the Storycaster is to help producers and creators expand their storyworlds and characters to new platforms without investing a great deal of time and money in adopting novel technologies.

First and foremost, the Storycaster functions as a remote cache which allows you to upload and manage your content via a single, integrative platform. Once you've imported all of your content to the server, such as videos, text files, photos, blogs, social media posts, you can define a distribution timeline to determine where, how and at what pace you want your audience to consume your story. You can also specify the level of audience engagement you hope to achieve for each piece of content by scheduling automatic push notifications and social media posts. The Storycaster then publishes content automatically on designated platforms according to the schedule set forth by the producer.

In practice, the Storycaster has several core benefits for both established and up-and-coming creator-producers. The service enables anyone with limited technical skills to easily implement and manage multiple platforms so that creative people can focus on storytelling and disregard technology barriers. The Storycaster schedules content publishing activities seamlessly across all platforms and social media networks, and facilitates the distribution of content on new platforms with increasing traffic such as connected TV and tablet devices. It also implements a unified approval workflow, promoting effective content management that results in fewer errors.

What about the bottom line? The Storycaster helps you monetise your content by executing a freemium model, i.e. you offer some content for free and charge fans for premium content. The service also lets you specify which pieces of content you'd like to run advertising across to generate revenue and can link existing products to your content to prompt sales via digital downloads or physical products. What's more, the Storycaster supports timely,

cost-effective development for multiplatform projects and gives you the ability to measure audience engagement, identify core fans and tweak your content accordingly.

Our greatest asset as producers is our fan base, and the Storycaster's number one priority is helping storytellers grow their audience by implementing a 'fan base cycle' aimed at converting casual viewers into fans. The Storycaster helps you to define engagement strategies around your content, designate engagement levels appropriate to specific platforms and schedule audience interactions. Simply put, you create the experience, and the Storycaster implements it with one or two clicks of the mouse. The service's automatic distribution function promotes word-of-mouth buzz by giving you the ability to create a website, YouTube channel, mobile app, Facebook fan page or connected TV app to cement your entertainment franchise in the public consciousness. It also catalogues the activity of your fan base, allowing you to measure the lifetime value of fans and consumers.

If you're working in a team setting, the Storycaster allows you and your team to remotely access and upload content with any browser, on any device (desktop or mobile) using any operating system (be it Mac OS, Windows, iOS, Android or Linux). Users can also access the Storycaster via several platforms, including mobile platforms like Android and desktop platform like Windows 8. Team members are given access to the Storycaster at one of three levels; some users are restricted to uploading content, while others monitor and review that material and report to the managing producers who have control the system's ultimate output.

Every piece of content produced for a single project is catalogued so that both team members and managers have an overview of the property as a whole. The Storycaster is also invaluable in facilitating online marketing campaigns. Rather than volleying emails back and forth between team members to set up and approve launch dates, the Storycaster provides a real time perspective of day-to-day tasks. Users can edit content directly on the dashboard without the need for accessing individual web platforms such as Facebook and Twitter. Not only does it allow you to upload your content in bulk, the Storycaster also functions as a scheduling and analysis device. The latest version of the platform includes additional tools applications so that producers can track more easily the performance of a property. For instance, YouTube only records the number of views you receive per channel or episode, but the Storycaster allows you to keep count of views per 'playlist', which encompass entire series or series' seasons.

Beat Girl was the first project we were able to manipulate using the Storycaster. We uploaded streams of content onto the platform, from Facebook posts and photographs to home videos and photo novels, and then synchronised a distribution timeline by defining when a product would be released on which platform(s).
The timeline for the Beat Girl franchise spanned the better part of two years. The Storycaster afforded us with an overview of the project no matter where or when we

released content. It allowed us to create a highly visible plan, upload and share content amongst our staff, and create a live schedule. Once online, the Storycaster publishes each piece of content automatically on designated social networks. It also creates a microsite which amasses all of the content related to the property and functions as a user map.

1st Platform & Proof of Concept	2nd Platform	3rd Platform	4th Platform	5th Platform	BIG PRODUCT 'Mona Lisa'
		Book		Fan Fiction eBook Publishing	
Pinterest	eBook @ wattpad	DJ Interviews Webseries		Soundtrack	TV Series
Webseries	eBook @ movellas	DJ Set List Webseries	Fan Fiction Competition	Movie Marketing Campaign	Movie
SOCIAL MEDIA ENGAGEMENT					
June 2012	July 2012	September 2012	November 2012	March 2013	May 2013

Figure 11. Beat Girl's distribution timeline.

Good content will engender user interactions, the most common of which are comments on social media forums. The microsite replicates each stream of commentary and reposts them collectively, so that users who use one service exclusively, like YouTube or Facebook, can keep pace with the larger community of fans. Additionally, the Storycaster tracks user traffic on a platform-by-platform basis, which enables us to determine which elements are performing well and why. Users can also set up, edit, and upload content, schedule its release and analyse audience behaviour via mobile apps, connected TV apps (like Samsung smart TV platform) and websites.

We've also developed a user interface for smart phone and smart television users which integrates with the Storycaster; these tools allow viewers to access all of our digital content in one place. On both the mobile digi-channel and the beActive TV app, users can 'like' and 'favourite' shows and episodes, keep up to date with news feeds, subscribe for notifications regarding up and coming content, as well as link to our online store where they can purchase premium content and merchandise. The user interface also offers a video on demand service where users can purchase feature films and documentaries. All of this information, from viewer preferences to online purchases, can be integrated with the user's various social media accounts if they so choose.

CHAPTER V - Marketing

- Build Partnerships, Beat the Noise
- Engaging Existing Communities
- Build Your Own Communities

Build Partnerships, Beat the Noise

As independent producers, we don't have hundreds of millions of dollars with which to market our entertainment products. To attract an audience and potential investors, we have to adopt a more innovative, cost-effective strategy which involves seeding a project online first. For established studios, marketing capital is a given, so it's unlikely they'll ever use this approach. What's the point of building a brand for two years when you can throw money into a major campaign or buy an IP with a pre-built audience?

What we do have as independents is the time, passion and personal investment to create better stories. We begin marketing a new project by partnering with companies and portals that already have access to the audience we're looking for. When we were developing Beat Girl and our latest property, Made with Love, two of the best books we'd ever produced, we decided to ask Wattpad, a digital publishing portal, to help us get the word out. Teens and young women are the most prominent demographic on Wattpad.com; they read millions of stories per month. In order to tap such a broad and active community, we needed to sit down with people, talk to them, and convince them that our intellectual property had a shot at making it big.

With that end in mind, we sent our head of marketing to Wattpad's headquarters in Toronto to pitch Beat Girl and Made With Love as hot new Young Adult and Chick Lit titles. The timing couldn't have been better; Wattpad was planning a month-long Chick Lit festival and agreed to feature our novel on their homepage alongside titles by Irish romancer Marian Keyes. The key to forging fruitful partnerships is to match your content to an appropriate portal so that your work augments the goals of your prospective partner.

One of the reasons we've had so much success with these properties is because we have an excellent partner in Wattpad, who believes in the projects and places our content on their homepage and at the top of the list in genre and keyword searches. This gives us the visibility that we need; the quality of the content sustains that visibility and helps us to build a fan base. If we had simply uploaded the novels they would have been lost among the millions of ebooks available on the site.

We dedicated the first two years of Beat Girl and Made with Love almost exclusively on marketing by giving away free content and building a strong fan base. We debuted Made with Love on Wattpad in February 2013, and we'll spend the next six months to a year marketing the brand. We'll produce Pinterest and Facebook fan pages, web novels and web series exclusively for marketing purposes. Only after the project has gained traction with our audience online will we begin to apply our monetisation

strategy. Down the line, we'll redirect our energies to creating premium content, such as a paperback book, apps, and feature films, to recoup our investment.

Identify the community or target audience you want to engage. Don't assume they'll come to you. The mistake that many producers make is to promote their property with a web or microsite, but the audience they've anticipated doesn't show. The trick is to find where audiences already exist so that you can launch your story in the most productive space. Always try to activate your target audience by serving them where they are.

Once you have defined a platform that already engages a subset of your target audience, designate which pieces of content you'll make available to them for free and which you'll set aside as premium paid content. Then solicit a meeting with your tentative partner and develop a marketing strategy based upon these and other alliances.

Forging a partnership typically requires that you strike a deal with the collaborating portal. You almost always have to give something away in order to secure such exposure, be it content, intellectual property, exclusivity or rights to ownership. In the past, we have partnered with Sapo.pt (in Portugal) and YouTube by streaming our content free of charge across their portals and then allowing them to sell adverts across that content. We then split the revenues generated from the adverts. You can also pitch for a deferral of revenues, in which you agree to a profit sharing scheme once your property begins to generate returns.

As unappealing as it may sound, be prepared to adopt a 'beg, steal and borrow' mentality if you expect to produce viable content in the current marketplace. In the month leading up to the release of the Beat Girl feature film, I made sure to have dinner with all of my relevant contacts, from cinema critics and theatre owners to the editors of Empire Magazine. I may not have the money to pay for a full-page advert in Empire or some other top tier publication, but I may be able to call in or ask a favour of someone in a position to give my project exposure.

To be successful, you need to strike deals with the owners of portals, websites and blogs who have access to your target audience so that they can give you more exposure than the average Internet user by putting your content on their homepage. One trick we've found effective involves offering your distribution partner exclusive content that audiences will respond to. Made with Love, for example, is only available via Wattpad.com. In return for exclusive content, Wattpad features our content on the front page of its genre searches and 'hot' reads.

More often than not, you'll gain more in the way of exposure by teaming up with a lesser-known portal who will make the effort to highlight your content. A major portal may draw a greater number of users, but these services can be less accommodating when it comes to promoting your content on their site. Very likely it will be overlooked amid the countless other streams of content published on the site.

When considering a digital partner, analyse the ways in which particular portals will benefit the growth of your property and fan base. Sometimes, it's better to ally yourself with a smaller platform who'll work to promote your content. For example, if you were to give non-exclusive content to three independent portals, in theory you'll have more viewers, but that's almost never the case. If, on the other hand, you give exclusive content to one portal, they get excited about the project and they make the push to attract and sustain an audience.

Alternatively, you can offer a portal something they need. For instance, when we were promoting the Beat Generation franchise, the Belfast Telegraph was looking to broaden its reach, particularly amongst teens and young adults. We provided them with video content which they featured on their home page to help them achieve their goal. At that time, the company was keen to partner with us in order to promote themselves as vanguards of popular culture. By using Beat Generation webisodes, the Belfast Telegraph was able to promote itself as a hip digital entity, while we were afforded with valuable exposure.

Before you pitch to a potential partner, study the nature and breadth of their output and identify what they might need to improve upon and expand their services. That way, when you offer exclusive content, the goals you have for your own product work to further your partner's. Create a proposal that excites them and meets their needs, and you'll have a partner that will work hard to promote your brand. As I mentioned earlier, we offered the ebook version of Made with Love to Wattpad.com in the run-up to their Chick Lit Festival. By giving them exclusive content to promote their festival and their service overall, we received unprecedented exposure.

Most of the partnerships we forge at beActive are of this sort: we offer content in return for exposure. No money is exchanged up front. If revenues are generated through advertising or sales (such as ebooks, videos on demand, etc.) we split the revenues with our partners.

Engaging Existing Communities

In the past, if you wanted to have an online presence you built your own website and waited for online traffic. Nowadays, people rarely visit websites. They frequent social media networks; they post comments on other forums and blogs.

We developed the romance Made with Love for a specific demographic – teens and young adults. To promote the piece online, we could have done one of two things. Firstly, we could set up a website called www.madewithlove.com, launch the novel in a digital format and flesh out the feel of the brand with graphics and images. We then invite our target audience to view our content by advertising with search engines or online publications that attract a similar community to our target.

On the other hand, we could locate a forum which already draws the return traffic of our intended audience. Wattpad commands an audience of more than ten million readers a month, most of which are young women. The most read genre among those hosted on the sight are romances. Rather than attempting to create a community from the ground up, I identify places where a large portion of my audience is and create content that feels organic to that forum and the behaviours of its fans.

When we were preparing to launch Beat Girl, one of my colleagues suspended her Facebook account. She had been an avid user of the service, so I asked her why she'd closed her account. She told me she had found another social network called Pinterest, which specialises in theme and trend-driven photo-sharing. She'd used Facebook to share photographs more so than communicate with friends, so it made sense for her to move to Pinterest because the service felt more organic for the way she uses social media.

I had never heard of Pinterest, so I created an account and reviewed the service's stats. At the time, their user base was eighty to eighty-five per cent female. I realised I didn't want to launch Beat Girl on Facebook; I wanted to debut it on Pinterest because that's where my audience had relocated.

We've established a procedure at beActive that requires all of our employees to be aware of this sort of market shift. We are all linked into a private database, and whenever a team member finds something that could be relevant – be it statistics, networks, viral videos, or services – they post it on the forum, and everyone is notified. Our eyes and ears are always open to what is happening in the world around us; that way, when the time comes to make a marketing decision, our choices are informed, and we can create a campaign that makes sense to our audience and the services they're using.

Once we discovered that a substantial representation of Beat Girl's target audience had moved to Pinterest, we decided to launch a photo novel on the site using the persona of the story's hero, Heather Jennings. Heather's 'pins' flesh out her explorations of music, fashion, and pop art and give viewers a visual segue into her dreams and her art.

By creating content specific to Pinterest, we were able to produce an experience that met (and, in some ways, surpassed) the expectations of the service's followers. As the first ever photo narrative published on Pinterest, Beat Girl took advantage of the site's popular format, while pushing the boundaries of what sort of content that format can support.

To anticipate this sort of shift in audience activity, it's vital to keep pace with the devices people are using as well as the manner in which they're using them. When producers approach me at conferences, pitching competitions and industry events, their projects are almost always overcomplicated. They think that, in order for their concept to be fresh, it needs to be available on all the social media services. They create Facebook, Twitter, and Tumblr accounts, create an app for smartphone users and a casual game for tablets.

An approach based upon the shape of your story, the media it lends itself to and the portals and sites your audience frequents is a much more effective approach. Think about your story and your target audience; pin down those networks, services and/or devices which cater to and engage that community and create experiences that, on the one hand, feel natural to the story and, on the other, integrate with the habits and day-to-day behaviours of your audience.

When I lecture at Power to the Pixel's 'Pixel Lab' and other training sessions, people always ask me what my motivations are for placing a project on particular social media sites. I always ask myself if creating a Facebook or Pinterest element suits my story. Are these elements important insofar as the telling of the narrative? Are the people I want to reach available on this or that platform? What kind of an experience should I create to engage them?

We began uploading collections of photos on our Pinterest account which corresponded with the plot line of Beat Girl and the visually charged subject matter, not only because Pinterest was a growing online community but because it created the context for us to tell the story we wanted to tell. The photo novel felt organic to the world that we were creating. If we'd written another type of story, or chosen a different sort of subject that was less girly or less soapy, it's unlikely that Pinterest would have contributed in a positive way to our audience's experience of Heather's story, and we would have sought a different platform.

Technology creates a lot of buzz with regards to 'the next big thing', most of which never achieve that level of notoriety. Expose yourself to the studies online, read the buzz and the marketing spin and learn how to recognise what's buzz and what's not. More so than anticipating the ways in which technologies will change, focus on how your target audience behaves and what informs their likes and dislikes. Learn how they consume content and determine what value they attribute to it.

Our first project, Sofia's Diary, was designed for teenage girls between the ages of 13 and 16. I'd happened across a study that claimed teenage girls weren't using their mobile phones to call one another, but to send text messages. When 'Sofia' interacted with her audience via SMS, they responded with the same sort of confidence and energy they would give a friend.

When a new technology makes its way into the mainstream, its creators have a vision of how their product will be used. Most of the time, consumers end up using it in a completely different way. SMS, for example, was intended as a simple device mobile networks used to monitor and control their systems. Suddenly, this feature began to be used as a communication tool, and today it's the most used data application worldwide as well as an entertainment and marketing tool.

Novel technologies, however engaging, are not fundamental to transmedia storytelling. New media technologies are in constant flux; there will always be a hot new

product to pique the curiosity of your audience. Rather than prioritising technology, pay attention to the ways people adapt to and manipulate technology so that your application of narrative is as innovative as the technology. Fight the temptation to use a new technology solely for its novelty factor. Transmedia audiences are extremely sophisticated; the last thing you want to do is alienate your audience by giving them the sense that your product is essentially a gimmick. It's crucial that you understand how your audience is using a new device or service so that you can create an experience that integrates your story with those behaviours.

At beActive, we have collaborative teams of technologists and content creators, but the story always prevails. The people who are writing the story always have the last say when it comes to the technologies we use. It's very easy to get excited by the possibilities posed by new technology. When we were designing the Final Punishment franchise, we were overwhelmed by all the tools we could use and experiences we could create. We could heighten the sense of the story's immediacy by interspersing content with clues, prompting the audience to jump from one platform to another to interact directly with the 'investigation'.

Final Punishment follows the interlocking stories of eight women trapped inside a high security Brazilian prison. When the surveillance connection to the block is lost, the women are targeted, one by one, by a mysterious killer. As the body count rises, the survivors hit on to the murder's modus operandi. The longest resident inmates are the first to go, and each of them is killed in the same manner of her own crime.

In a race against time, the prisoners join together to find the code that will open the prison doors so they can escape from the murderer. The property includes an online alternate reality game which prompts users to collect a series of clues on websites, social media profiles, blogs, and videos to help the inmates crack the code. We also set up a telephone number that allowed viewers to call the director of the prison.

To plug the web series, we broadcast adverts in municipal lifts. Between weather forecasts and news headlines, commuters on their way to the office were confronted with a blast of static interference. A terrified woman appeared on screen and said, 'You! Yes, you! I need your help! I'm going to be killed tonight!' The feed would then cut out, and the web address to the online series flashed across the screen. It was a very successful tactic; each morning we saw a spike in online traffic.

Applying this sort of technology to thrillers and whodunnits amplifies the mystique of the storyworld, but this technique is not suitable for the majority of stories we tell at beActive. There's a big difference between having Julie Quinn of Made with Love ring a romance fan and the police chief contacting a viewer 'investigating' the same crime.

Exciting as they may be, these sorts of projects become so complex and demand so much time from a producer and his audience that only a fraction of his viewers

take the time to explore all of the amazing things he's developed. The project becomes something extremely exclusive, which the producer cannot market. He's spent a lot of time and money creating an exciting experience, and then ninety-nine per cent of his audience choose to watch only the linear content.

Eventually, this trend of attaching alternative reality and conspiracy-type projects to transmedia will evolve into a broader conceptualisation of form. While transmedia is indeed an ideal format to create a complex interactive world, it's also a powerful mode for telling stories about day-to-day dramas. At beAcitve, we try to use the transmedial approach to tell more relatable stories, comedies and dramas about ordinary men and women. With a strong plot and three-dimensional characters, you can utilise multiple platforms without engineering a complex, problem-solving mechanism.

Further problems can arise if you begin to introduce technologies which are not genuinely integrated with your story. These pieces of content tend to function as games; they're fun to interact with once or twice, but they do not move your story forward. You run the risk of boring your audience with a gimmick when you could be focusing their attention on character and narrative. Whatever technologies you choose to employ, they should serve your story and make it more immersive. My goal is to transport the audience from their couches and theatre seats to a space inside the screen.

Multiple Platform Experiences

Nowadays, there's a lot of talk regarding the 'two screen experience', which involves a viewer toggling back and forth between two devices and streams of content. 'Two screening' can be casual and non-integrative, such as watching a television show while shopping online or chatting to a Facebook friend while keeping an eye on a football match. Live events can have boring moments and they tend to incorporate multiple breaks in action, so if the viewer has a way to engage with the content beyond a single platform, his experience is much richer. Two screening can also incorporate a formal interactive link through multiple services and interactive experiences. Say there's a new contestant on American Idol or The X Factor; you can log on to the show's website while they're performing and tell the world what you think.

For these types of live broadcasts, two screening makes sense, but it's probably not the best approach for telling scripted stories. When you're posting scripted content, it's important that your audience pay attention to the plot line. It doesn't make sense to distract them with push notifications on a smart phone or tablet or prompt them to jump between two screens.

Our marketing strategy involves maintaining an awareness of the technologies that are current and forthcoming, immersing ourselves in those contexts, and identifying

shifting behaviours in our target audiences by creating a dialogue between ourselves, our users and our service providers. We knew that we had a product geared toward a female audience with Beat Girl, so we made a point of exploring Pinterest as a possible promotional avenue; we liaised with the service's creators and directors in order to create a concept that would best engage with Pinterest's audience.

It's up to producers and creators to design experiences specific to the language of a particular platform and the expectations of its audience. When we log onto Facebook to view content, we expect to experience something that replicates the way we use the service. We use Facebook to connect with our friends and acquaintances and to check out what they're doing throughout the day. If you want to tell a story using Facebook, you need to create something that has the look and feel of a real person's life, one punctuated with events, photographs and videos. It should have a chronology. As tempting as it may be to place stand-alone narrative content on Facebook such as a scripted web series, keep in mind that your audience is not on Facebook to watch videos. They're there to keep pace with events, photos and status updates. Learn the modes of expression unique to Facebook, and tell your story using those modes.

What matters most is how people consume content, and those behaviours depend a great deal upon their expectations of a particular format or platform. As producers, we cannot expect an audience to change their behaviour just so we can tell them a story. It is the producer who needs to adapt, not the audience. When we watch television, for instance, we expect it to conform to its established format. We expect dramas to run from fifty minutes to an hour and sitcoms for half an hour. We expect cliffhangers before ad breaks. If a television producer suddenly creates an experience that's totally different, his audience will reject it because it's not what they expect from television. Be careful not to alienate potential fans by radicalising a particular genre or platform.

Off-Line Promotion

Unfortunately, promoting digital media doesn't square with a Field of Dreams sort of technique; if you build it, they more than likely won't come. To attract viewers to our online content, we always run content offline, from radio segments to newspaper columns. There are two advantages to tapping into periodical broadcasts and publications: they furnish a pre-built audience and are persistent in plugging your content throughout the week.

A morning radio show or an afternoon chat show, for example, air five days a week. They may have hundreds of thousands of people tuning in day after day. By partnering with more traditional broadcasters, you can remind your audience five days a week that your brand exists. A successful marketing campaign requires that you work constantly to draw people to your online presence. Otherwise, they'll be distracted by other media. Periodical offline

media such as radio broadcasts and newspaper advertising has the power to keep your story in the minds of your viewers. These sorts of linear media have the advantage of pre-built audiences. They allow you to plug into an already functional circle of engagement and remind people that you have a product or a collection of content that's worth coming back for.

We make every effort to create buzz through offline media. We feature characters on radio soaps and Q&As, highlight particular themes or plot points in 'character' penned columns, and package webisodes as short segment 'snack TV' for broadcasters to air on a daily, weekly, or monthly basis. Linear media's biggest advantage is its command of a consistent viewership. Building a strong fan base is not necessarily a matter of boosting viewer numbers. Scores of one-off views do not amount to a loyal viewing community.

Your goal is to bring a core audience back to your content over and over again. Invest as much of your time and resources as possible to create content of such high quality that people will continue to follow the brand and incite others to do the same through word of mouth. In the first weeks after your initial product push, you'll have a flood of viewers, but over time people will be distracted by competing content, and your audience numbers will taper off. Of the ten thousand individuals you draw to your brand at its first release, you may have one hundred return viewers.

To ensure that your core audience and new viewers continue to seek out your content, it is vital that you employ a marketing strategy that continues to attract more and more people to your content. Make your initial launch with a partner, like YouTube or Wattpad, which drives consistent viewer traffic. Then integrate your release of complementary content via digital and traditional platforms, which draw smaller viewing communities. To ensure that your story reaches as many people as possible, negotiate a recurring re-launch schedule with your partner so that your content appears on their homepage or in their column every week or month. Strive to build a network of smaller community banks that will spur new and returning viewers to continue to check out your content online, and you'll be able to grow your brand gradually over time.

Building Your Own Communities

The key to creating and maintaining your own viewing communities is continuing to diversify and improve the ways in which you communicate with your audience. Think of each interface and its companion content as a chance for you to power the circuit of engagement throughout your marketing campaign.

Prior to launching your campaign, ask yourself what you want to achieve. What is the message you want associated with your content? Is your ultimate goal a book deal with a major publisher? Perhaps it's licensing the format of a television series or film. No matter what you are trying to promote, be sure to have a clear sense of your goals so you can tailor a campaign to best meet them.

Be sure to secure a marketing and/or distributing partner appropriate to your project before you dedicate your resources to creating content. Every one of the transmedia projects we produce at beActive is facilitated by a co-marketing partner. Identify a primary distribution partner whose service not only accommodates your target audience, but also showcases or enriches your content in some way. This may be a web service or portal, app distributor or social media site. This applies to both online and offline campaigns and advertisements. At this point, you should also be thinking about the sort of copy you'd like to create for press releases, blogging and other online activities.

The Engagement Cycle

Once you have forged a strong partnership with a co-marketer, you're ready to put the five steps of the engagement cycle into action. The first step involves devising your campaign's call to action. The jaw-dropping lift ads we ran to promote Final Punishment called our audience to visit the property's website. The banner ads we ran alongside the ebook version of Aisling's Diary prompted readers to view each chapter's webisode.

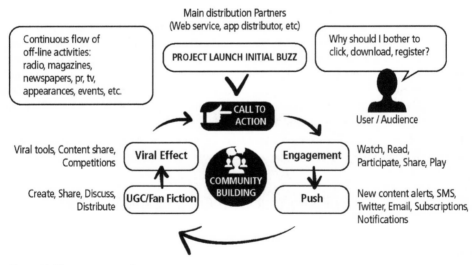

Figure 12. The engagement cycle.

No matter what it is, the call to action should incentivise the user to interact with your content. He visits the Final Punishment website and is rewarded with clues to uncover the prison code. He watches the Aisling's Diary webisodes and comments on our YouTube channel. Think of the call to action as a jump start to the engagement cycle; it's the spark which drives the user to 'click' and read, watch, play, or share.

To keep the cycle of engagement going strong, you need to provide your user with the 'why'. You've encouraged him to make that initial click, and now you need to reveal that his interaction is part of a much bigger plan. Provide him with a map of your storyworld so that he can visualise where the full experience of your project begins and ends. Even though he may enter this world in medias res, he interacts with content in a linear way, moving from A to B. It's vital that the user has a map so that, when he jumps into the story, he'll have a sense of what comes before and after that particular moment and, more importantly, a desire to see what happens next.

The information and the path you provide for your user needs to be very clear so that he'll know what he has to do to connect with your content. You might ask him to read, participate, share, or play. Then work to convert this would-be casual visitor into a fan. As I mentioned earlier, give him something that will encourage him to continue engaging with your content such as a prize, a cause, peer status, or fun and entertaining content.

Some users will take you up on your offer and click a second or third time, but after five seconds or minutes he'll get bored, or something in his life will distract him or otherwise demand his attention and he'll disengage. Keep in mind that you do not have the advantage of a pre-built audience; once your users leave your web page or YouTube channel, it's likely they'll never come back.

The third step in the engagement cycle involves your implementing push activities such as SMS alerts, Twitter and Facebook notifications, email messages and content subscriptions which prompt prior users to continue to connect with your content. Whatever 'push' techniques you employ, your message to your fans must be sexy. Whether you are prompting them to read more, watch more, register to a subscription, download content or make a purchase, each push communication needs to elicit an action. It should also present the user with a goal that tells him why he should bother to click again. If he is seduced by the push message, he will engage with your content for five more seconds or minutes, and the engagement cycle begins again.

Then, to deepen that cycle, we ask our user to not only consume our content, but to participate with it. He can join in a comments forum, generate his own content, 'like' and share content with his peers. It is this sense of participation that grows a community. Your fans are no longer passively reading or watching your content; instead, they're interacting with it and inviting their friends to do the same.

Every community (and every property) needs a home; whether it's a website or a Facebook fan page, users need a place where they can express themselves. The fourth step in the engagement cycle involves building a visible community 'home', such as a forum or a website with regular visitors and contributors, which reinforces your community's sense of identity and significance. It also provides you, the producer, with a space in which to nurture and grow your audience. Use your community 'home' to promote participation by taking advantage of the human love of discussion and controversy. Give your fans a

chance to express their opinions and take sides. These online battles spice up audience participation, but be sure to remain in control so as not to damage your brand.

People are better able to engage with other people than with abstract ideas or concepts. Your communications with your audience should, therefore, be character-driven. Choose the character or characters that best represent your property and give them an online voice your fans can relate to and interact with. If you have strong characters, viewers will be more willing to tune in to webisodes, browse the hero's Facebook profile and perhaps 'like' the content.

To spur your audience on to the second level of engagement, you can call for specific types of active participation or user-generated content. Fans might be asked to snap a photograph of a friend in a Collider t-shirt, make a comment on a fan page or design a logo. These activities involve individual viewers in the creation of the overall experience without demanding extended periods of engagement. You can also incorporate viral tools which enable users to share content with a single click. As with your push communications, be sure to give your audience something in return for sharing your content.

The third and highest level of engagement occurs when a fan is so enamoured with your story and your characters he commits himself to writing his version of the story in the form of a chapter, short story or novel. These uber fans dedicate hours at a time to writing a piece of fan fiction that might place him in the upper echelons of the community. We've held contests with several of our properties, including Aisling's Diary and Beat Girl, which promote engagement by rewarding our top users through community recognition and publication.

No matter how effective you are at motivating your audience to participate with your content and others online, it's inevitable that user numbers will drop off between promotions. The fifth and final step in the engagement cycle is ensuring a more or less constant flow of user traffic by establishing monthly goals and defining ways to promote content to new and existing users.

Whether it's using public relations campaigns, adverts, publicity stunts, online and offline media, you need to come up with new ways to generate peaks of traffic. Establish a continuous flow of promotional partnerships with radio broadcasters, magazine and newspaper publishers, PR agencies, television broadcasters, and event coordinators. Services like Google AdWords or Facebook Ads are further options to maintain user traffic.

Establishing an engagement cycle isn't enough to grow a successful transmedia brand. You need to ensure that the cycle continues by creating and launching promotional campaigns at every single step in your transmedial plan to spur even more people to join your community. During the lifespan of a viewing community, you should have at least one major campaign each quarter which is accompanied by several minor activities to keep the flow of traffic moving.

CHAPTER VI - Monetising Digital Content

- Creating the Right Context
- Transforming Project to Product
- Expanding Your Property
- Scaling Up

Creating the Right Context

Let's say you've launched your story online and established a strong fan base. People love your content. Now you need to create a few experiences they'll be willing to pay for. But keep in mind that audiences pay for emotional connections. You need to create the right context which will motivate them to pay for your content.

Providing your fans with the opportunity to buy exclusive content or merchandise is one way of turning a fan into a motivated buyer. He may have seen Star Wars three hundred times and own an extensive DVD and memorabilia collection; nevertheless, if he's presented with a box set that includes a figurine that will never be relaunched, he'll want to buy the set for his collection.

You can also prompt your fans to make purchases with a need specific to a piece of content or a platform. If they're playing an app-based game, for instance, give them the chance to make in-app purchases of exclusive weapons or codes that will allow them to speed their progress in the game. Alternately, you could offer the first few rounds of play free of change; if fans want to continue playing, they'll need to purchase access.

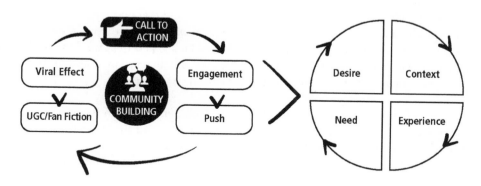

Figure 13. Turning fans into buyers.

If you're staging a live event like a concert or a panel discussion at a book fair or film festival, be prepared to follow-up the live experience with merchandise like CDs, t-shirts, books and DVDs. When I speak at conferences and on industry panels, I always wrap up my discussion by referring the audience to Amazon, where they can continue to read about my work and transmedia production if they purchase my books. Invariably, a number of copies are sold overnight simply because I pitched the content in the right context.

Once you have built a community of fans who like your characters and the experience you're creating, bring out products that speak to their needs and the context of their viewing. There are two ways you can go about creating a product based on your brand. You can partner with someone who is established, such as a traditional publisher. This was our approach with early projects such as Sofia's Diary; we sub-licensed the book, but more and more we are shifting our focus to self-publishing. Typically, we self-publish the first edition of our novels. For example, Made with Love debuted on Wattpad; our ultimate goal for the brand is to attract a publisher who can then market and distribute it globally. Before we can leverage the best deal from a publisher, we have to prove that we can transform the millions of views the book received on Wattpad into people who buy products. To do so, you must show your potential partners that you have a franchise of several products and a fan base which is willing to spend money.

Transforming Project to Product

When we're developing a new brand, we choose to create products we feel the most comfortable fabricating, distributing and monetising. We always include a textual element, be it a novella or a longer work of fiction, because we have a long tradition of producing books, and we're well-versed in how the publishing world works. What's more, the types of stories we create lend themselves to pop and genre fiction, which are both effective and entertaining ways to introduce our storyworlds to an audience.

We also have a good deal of experience producing web series, television shows and feature films. Two years ago, we started a department that develops mobile games and apps because we wanted to learn what people expect from these platforms and become more comfortable self-producing them. Having said that, we don't want to be a games company, but we do want to have some intelligence in-house so that we can complement our stories with games and apps if necessary.

Recently, we produced our first comic with Collider, and again it was a learning experience; we knew nothing about comic books. Because of the subject matter and our target demographic, we thought a comic book would be the perfect companion product and a unique way to introduce the story. We therefore hired people who knew about this world so we could create a comic book. Choosing which media to incorporate in our products involves a combination of what we feel comfortable with and what makes sense to the story. Of course, sometimes the story lends itself to media or merchandise we don't have any experiential knowledge of, so we then license that product to a third party who specialises in magazines or apparel. We didn't know the first thing about magazines when we were developing the Sofia's Diary brand, but we knew the medium was perfect for our story and our target audience, so we licensed the brand to the teen magazine publisher Goody, who helped us to produce the magazine for over a year.

Our partnership with Goody was not typical of the majority of the licensing deals we make. In general, when you license a property to another production company or a manufacturer, you set the rules with regards to how your story will be adapted and monetised. When we teamed up with Goody, fifty per cent of the creative work was to be done by our own team and fifty per cent by the publication's staff. Unfortunately, each team had very different ideas about the value of our brand and how best to create a salable product. The entire concept of the magazine was reworked with every issue to the point that each individual issue seemed like a different product. Keep in mind that everything, from content tone to packaging, will determine whether or not you maintain an audience.

Working with mixed teams requires that you spend a good deal of time and energy managing egos. In fact, the majority of our past failures were due to the ways in which we handled our partnerships, not poorly executed stories or nonexistent audiences. Even if your creative teams work well together, your partner may not have the reach you expect or the right sorts of distribution for your product. Some time later, we partnered with a gaming magazine to promote and distribute our alternate reality project Dark Siege. The multiplatform concept included a novel and an interactive game; audience members read a chapter and played the corresponding game online. The magazine publisher we teamed up with had a strong connection with the gaming community. We were certain we'd chosen the right partner for our brand.

Problems arose when our joint team attempted to promote and sell our product. The publisher's distribution model was based on magazine sales. Therefore, they distributed the Dark Siege book alongside their own products on racks in small shops. Our consumers, meanwhile, were on the lookout for Dark Siege in book shops and the books were not being sold there. In this case, we chose the wrong partner to distribute our product.

The lesson we've learned from years of variously successful partnerships is to define our own core competencies, and then seek out partners who can advance our project by offering a skill set or a product we cannot create in-house. This is not to say you should be discouraged in taking on new tasks or working with unfamiliar media, but be prepared to allot the time necessary to learn these new skills. Looking back on our experience with both the Dark Siege book and the Sofia's Diary magazines, we would have been better off licensing the brand altogether.

Even though there can be drawbacks to creative partnerships, there is no more effective way to grow your concept into multiple platforms. When you are developing or expanding a project, begin working within the platform you feel most comfortable with. Then partner with companies who can help you develop further content for media you're unfamiliar with and products you do not have the means to produce in-house. Their specialised approach will be more effective than your own. To be transmedial, you don't need to learn how to do everything; you need to partner.

Film producers are very savvy at forging these sorts of partnerships because they've been co-producing between territories with other film and television companies for decades. Now is the time for production companies to take that mindset a step further and co-produce with games and marketing companies, social media networks and publishers so they can take advantage of a multiplatform approach without having to defocus on what they do best.

As I mentioned earlier, the context you provide for your viewers to engage with your content will be a major factor in determining whether or not they'll be willing to pay to experience premium content and services. If they can't get it anywhere else, your audience will be more inclined pay for your content. One of the reasons Apple's iPhone app store is so successful is because it's a closed system. If you want to purchase a premium app for your iPhone, there is no other way to do so than to access the Apple store. Products which provide an exclusive experience and are only available via a unique platform are perennially popular. What's more, the store's user interface is simple and integrative. In other words, content can be purchased and accessed across multiple platforms with a single Apple ID.

Publish Yourself

We use a publishing on demand system provided in the UK and US by INGRAM. This system allows us to place our books in major online book stores, including Barnes & Noble and Amazon.com. To bring a book to press, we contract a writer, editor, and proofreader who work in tandem with our graphic designers to create a finished product. Then we distribute the book via INGRAM. If you don't have a designer or proofreader, hire independent contractors to perform this service for you.

When you adopt a transmedial approach, you no longer need a publisher to produce your books or a record label to produce soundtracks and CDs. At beActive, we do everything we can to self-publish content in the earliest stages of development. For example, with the Made with Love brand, we self-published via Wattpad.com, attracted a fan base that is 2.5 million readers strong, and are now shopping the story to established publishers who can then scale-up the production and distribution of the piece. Meanwhile, we are using digital platforms such as Amazon's Kindle and Apple's iBooks, which allow us to bring our products to market right away.

If you are interested in publishing a paperback book, Lulu.com is an excellent go-to service. They will help with editing, designing and formatting your book; they also provide printing, binding and marketing services. Google offers a comparable service for self-publishers. If you would like to create a digital version of your book, you have several options to consider. Amazon.com's website provides valuable information which will help you create a Kindle ebook version of your paperback. With Lulu.com, you can

convert and publish your book in the iBook format; alternatively, you can go directly to the Apple iBookstore. Bookbaby provides several publishing packages, which include digital distribution to the iBookstore, Scribd, Barnes & Noble's Nook, Amazon's Kindle, Kobo, eBookPie, Copia, eSentral, Baker & Taylor, Reader and Garderns Books.

If you have a soundtrack or a CD that complements your property and you want to make it available on digital services such as iTunes and Spotify, you can sign with a distribution company like Tunecore or CD Baby. Both have easy to navigate user interfaces that allow you to upload and manage your tracks, while making them available in all of the major online music stores for a small fee.

You can develop and publish games and apps for multiple platforms using Apple's app store, Google Play, and Samsung's app store. Each service has a step-by-step 'developer console' which allows you to upload, publish, promote and update your applications.

The publishing and distribution platforms that we use at beActive include:

Paperback Books:

Lulu.com is an online self-publishing service that allows you to 'easily publish your book in any format including high-quality paperbacks, hardcovers or eBooks. You print only what you need and therefore assume no inventory risk. Volume discounts start at fifteen copies. You also have control over your content's copyright and set the price of your book.'

Figure 14. Lulu.com.

Amazon/Kindle eBooks:

You can 'publish your books independently with Kindle Direct Publishing (KDP) on the Amazon Kindle Store.' You can 'make changes to your book at any time, publish once and reach readers worldwide and get to market fast. Publishing takes less than 5 minutes. Your book appears on Amazon within 24 hours.' Customers in the US, Canada, UK, Germany, India, France, Italy, Spain, Japan, Brazil, Mexico, and more earn 70% royalty. The service also allows you to publish in multiple languages including English, German, French, Spanish, Portuguese, Italian, and Japanese.

Figure 15. Kindle Direct Publishing (KDP).

Other eBooks:

If you're interested in self-publishing a book for iOS devices such as the iPhone, iPod Touch and iPad, you can upload your work to the iBookstore using a free software package called iBooks Author. Apple takes a standard 30% cut of your profits. Bookbaby.com 'offers the widest eBook distribution network for indie authors: 170+ countries, twelve stores, one BookBaby Account.' BookBaby collects one hundred per cent of your net sales from retail partners and pays you that one hundred per cent.

Figure 16. Bookbaby.com.

Mobile Games and Apps:

At beActive, we self-publish our own games and apps to the Apple app store, Google Play and Samsung apps stores. All three of these services allow you to upload your digital application to be reviewed and certified by technicians before they're placed in online stores. You can update your apps at any time and monetise them by selling advertising or sponsorship rights to your app or offering premium in-app content for a fee.

Figure 17. Samsung Apps.

Music:

We use the TuneCore Music Distribution service that 'puts your music in over seventy-four of the most popular digital stores around the world', like iTunes, Amazon MP3, Google Play, and Spotify. The company is a preferred iTunes Music Aggregator which charges $9.99 per single and $29.99 per album. Users retain 100% of their music's rights and 100% of their sales revenue. CDBaby is the direct competitor of TuneCore that allows you to upload albums or singles or distribute CDs and vinyl and sell online at CDBaby.com, 'as well as some of the largest music retailers in the world, such as iTunes, Amazon MP3, Rhapsody, eMusic,

Figure 18. Tune Core.

Spotify. If you're selling CDs with the service, your album will be available on CDBaby. com, Amazon Marketplace, and the Alliance Entertainment distribution network which includes thousands of brick and mortar record stores worldwide. Whenever you sell a download or a CD, CDBaby adds that money to your balance (which you can always see in your member accounting area). You set your pay point and they'll pay you whenever your balance reaches that amount. Payments go out once a week.'

Video on Demand

Distribber is an online film distribution service which allow you to choose from specific retailers including iTunes, Amazon, Netflix, Hulu and Cable VOD. You'll be charged 'a one-time fee for store placement; there are no back-end fees. You keep 100% of your revenues. If iTunes declines your film, we'll refund your money minus $39 for processing. The encoding and QC processes will take (on average) ninety days for your film to go live. Sales reports that detail collection stats by each platform are available upon request. You keep 100% of your money. Distribber pays you at least every three months either by check or PayPal.' Under the Milky Way is a similar company in Europe.

Figure 19. Distriber.

Expanding Your Property

Once you have succeeded in translating your storyworld bible into a production plan, published content, incubated your story on and offline and adapted it to the likes and dislikes of your audience, it's time to plan for the expansion of your property into other, more mainstream formats. If you have followed the advice I set forth in Chapters I and III regarding the creation and evolution of your storyworld bible, you should have a cache of characters and plot threads that will allow you to expand your story across new platforms. At this point in your production plan, you should be selling products, e.g. mobile applications, books or games – perhaps not in huge quantities, but you will have a sense that there is a demand for your content in the marketplace.

To expand your property you need to go mainstream, and the way you go mainstream is more than likely to partner with someone else – a film company or publisher – who is bigger than you. You're ready to make the move to television by co-producing with a network, to sublicense a book or soundtrack to a major publisher or music producer,

to sell your content to a triple A games company, or to partner with a film company to produce a feature.

Think of expansion as the third stage of your production plan before you scale your property up to an international level. More than likely, there will be overlap between your efforts to expand and scale up your brand as your expansion partners may have access to international markets.

Made with Love, for example, began as a scripted mini-series which we later developed into a book. The adaptation introduces plot elements and characters, which give us a much richer world to work with, but the storyline is still relatively limited. It runs the course of six weeks and revolves around two central characters. Because we took the time in the early stages of the project's development to create an intricate storyworld, we have enough material to create a television series and, if we need to, strong enough characters to develop a second series. Our intention, however, remains the same: to develop the story intrinsic of platform, test it with a real audience (in this case, the ebook was launched on Wattpad) and examine consumer feedback on plot points and character development.

At the expansion stage, you have time to fix any problems you may have with your subject matter or the voices of your characters. It's too late to make such foundational changes after you've shot a ten million dollar film or two to three television episodes. We always test our stories before we commit to producing something more expensive. This involves creating more content and prompting the audience to explore the characters and their stories on different platforms.

When we began to expand Collider across multiple platforms, we brought in graphic novelists, screenwriters and game designers to flesh out the characters and the plot lines through a six-year time span. As one of the most complex storyworlds we've created, it was a significant challenge to maintain Collider's integrity across each of its manifestations. At one point, I had to abandon several ideas for the feature script because they would contradict elements in the preexisting graphic novel and game. Brand consistency should be among your top priorities throughout your project's development. If you want to maintain the loyal fan base you've created, it is crucial that you take pains in the development so as to provide your audience with a seamless entertainment experience.

Scaling Up

Scaling up is the process by which you translate the successes your brand has had on a localised to a global scale. Our strategy at beActive begins at the earliest stages of development. No matter the project or our overall production plan, we do everything we can to carry off the initial stages of production, marketing and distribution in-

house. This process involves seeding free content online to grow a fan base, devising partnerships, and creating products such as digital and paperback books, CDs, and merchandise we can sell in online stores to generate the notion that we have a brand. We give away three quarters of our digital content for free and try to generate revenue with premium content and non-digital products.

Once we have proven that we can convert our viewers into buyers, we approach bigger production houses and publishers and pitch our brand using our audience as currency. By sub-licensing the brand to these companies and their distributors, we're able to scale up our product's reach in additional territories across the globe. Most recently, we sold the formatting rights to the Beat Girl franchise to Ben Silverman's company Electus so that the brand can be adapted to the US market. Our Collider franchise, meanwhile, is distributed by Content Media Corp around the globe.

Alternatively, you might choose to partner with a production company with a stronger track record that can bolster your marketing efforts. Simply put, the key to scaling up is to partner, partner, partner. Remember, you can't do everything. Work with producers if you don't have experience in film, with games companies if you're unfamiliar with software design. License your book to a publisher to ensure that your story will receive proper global marketing and distribution. Partner with a broadcaster to create a television series. You've done the hard work, gotten traction with your audience and are selling units; now it's time to partner up using more traditional production models. You can achieve this end by licensing your content to local and global producers and distributors.

Licensing Your Content

Licensing gives you the opportunity to realise a fresh and further reaching dimension of your brand. There are several ways you can go about licensing your content to other, more substantial companies. You can re-edit and repackage your webseries and license to a broadcaster or a paid video on demand service. If you developed your product initially as a game or webseries, you can license the format of the brand, which involves selling the rights to the characters and storyline to be redeveloped into additional platforms such as apps and console games or bigger productions, such as primetime television series. You can also license a self-published soundtrack to a music label.

Alternatively, you can license your characters or your overall brand to a licensing agent who has a relationship with global manufacturers and distributors. Like a talent agent, a licensing agent liaises with toy and clothing manufacturers in order to connect your brand with a massive, global community. It's this chance to tap into the biggest pre-built communities that make product licensing the producer's Holy Grail. No single piece of content, not even a wildly successful blockbuster film, will generate the sort of money that can be made through licensing deals.

In the past, we were able to create and sustain online communities, but there was a limited amount of tools available for us to create and distribute our own products on a global scale. Now, with services such as INGRAM and CD Baby, independent producers can self-publish their own content and distribute worldwide via online merchants. But there are drawbacks to self-publishing. Foremost, your product will not benefit from the highly-efficient marketing and distribution machine that is the established publisher or record label. No matter how well you manage your self-publications via digital platforms like INGRAM and CD Baby, you and your brand will benefit more from partnering with prominent publishers who have decades of experience and well-worn distribution channels.

Products you can license:

• Books and ebooks can be licensed to publishers. Characters can also be licensed to publishers who want to develop a book.

• Audiovisual content produced for the web can be licensed to be repackaged as television content. It can also be licensed as is by a broadcaster or by paid video on demand services such as iTunes, Netflix and Hulu.

• The concept, format, and/or characters of your brand can be reversioned as a television show (just as our property, Beat Girl, is being reworked by Electus for the US market).

• A soundtrack can be licensed to a music label.

• Your brand's characters, format, or concept can be licensed to a games company or app developer.

• Your characters and logo can be sold to a licensing company (or agent) in order to produce consumer products.

• You can also license your characters for live events such as Sesame Street Live and Scooby Doo Musical Mysteries.

Figure 20. Beat Girl products.

Going International

There are two ways to scale up your brand to an international level. First, you can develop a niche product, the concept of which is generic enough to transcend language barriers and cultural nuance. You can reach a global market via the digital platforms online which do not operate on a border-by-border basis. Conversely, you can develop a product more attuned to local needs which can later be reversioned into different languages and cultural contexts.

Beat Girl, for example, is a mainstream coming of age story which we promoted via popular portals including YouTube, Facebook and Pinterest and a localised marketing campaign in the UK, Ireland and Portugal. We launched the brand across these territories because we have a certain amount of control over these 'home' markets. Even though digital platforms allow you to reach a global audience, you need to supplement your marketing strategy on the ground with contacts who know the market and culture of a particular territory. Once we had secured an audience of one million plus viewers and were selling brand-related products, we pitched the property with American and Australian production companies with a global reach to be licensed and reversioned. The Los Angeles-based house, Electus, licensed Beat Girl.

The Collider franchise required us to take a different approach due to the nature of its subject matter and narrative style. Geared toward sci-fi and thriller enthusiasts, Collider demanded a marketing strategy that connected small, niche communities across the globe. We developed a single version of the script and released content globally via popular web services and blogs. If you are producing a property intended for a niche audience, licensing will be a challenge. Specialised content that will prove difficult when it comes to reversion and has a limited audience make pitching these sorts of projects difficult on a territory by territory basis. Focus on creating a global strategy using digital platforms, from websites and forums to blogs and fans pages, to engage a world-wide community through common interests.

CHAPTER VII - The Future of Transmedia

- More Than a Buzzword
- Experience Design
- Making the move from Platform to IP Funding
- Global Distribution

More Than a Buzzword

At present, the term transmedia is being used to define various approaches to storytelling, entertainment marketing and distribution. As I pointed out in Chapter I, transmedia can be subdivided into three genres: the brand extension, the digital-only product, and organic transmedial franchise. In my opinion, it is best described as a storytelling process. It's not a book or a game or a web series. It's a world populated with characters who interact with one another and create conflict and intersecting plot arcs. It's only when that storyworld is well-defined that the producer can start to open windows to that world that allow the audience to connect with the story. True transmedia productions apply the right media to involve viewers in different parts of the story.

In my view, one of the major changes we'll see in the future will be a clear definition of terms and buzzwords so that, when we are discussing transmedia, cross-media or multiplatform applications, we'll know exactly what we're talking about. This is not to say that any one of these terms is incorrect, but if we are to effectively promote transmedia and other forms of digital content production and distribution if the industry at large does not know what we do. Nailing down our own terminology will help us to show the industry the real value of transmedia. Once we clarify the many different approaches to telling stories using new digital platforms and the ways in which those platforms can be utilised to enhance audience experience, the establishment will begin to understand the advantages of transmedia's production and business models.

The second change I anticipate in the future involves the transmedial funding model. Currently, there is some movement within traditional funding institutions; broadcasters, film funds and private equity investors are all adapting to the new world of digital media. Some film funds are already investing in digital content, video games and digital marketing campaigns. Others are developing 'experimental' and 'innovation funds', so projects that are not based on film or television formats can also benefit from an injection of early stage funding.

Furthermore, future industry leaders should subdivide funding budgets into two categories. The first is intellectual property funding for early stage development of concepts and stories which are not (in their initial stages) aimed at a specific traditional platform. The second is platform funding, which facilitates transmedia producers in developing products for specific platforms, from television shows and feature films to mobile applications and videogames (in other words, scaling up incubated properties).

The third change I anticipate involves the way in which transmedia content is distributed. Our industry is very effective at selling and distributing cans of 35 millimetre film (or DCP hard drive masters) and Digital Betacam tapes, but we have yet to develop a strategy for distributing combined entertainment projects that include audiovisual and digital content elements. As soon as we can create an infrastructure which will enable the international market for transmedia properties, and revenues can be made from their global exploitation, industry front runners will start to pay more attention to multiplatform storytelling as a viable alternative to more traditional single platform or linear storytelling. Investors will then be more willing to fund these sorts of projects.

The Evolution of the Entertainment Business

In the 1990s, the global IT culture could be described as platform-centric; the industry based its output upon the types of devices we used to consume content on. One of the effects of this platform-centric mode was a clear delineation between the types of content people came to expect on different platforms. People were only able to access a specific type of information, show or game by using a specific device. We expected to receive text messages on our mobile phones, play games on a console, watch short videos on our computers and television shows on TV sets.

These delineations have begun to break down as different types of content are now available across a multitude of platforms. Services like the BBC's iPlayer have adapted to consumer demands and can now be accessed on many kinds of devices. This shift presents content producers with a bewildering riddle. If all content is available on a multitude of platforms, how do we know what the user expects when they turn on their iPad or television?

In the past, we leaned in to use and interact with our computers. We sent emails, work documents and chatted with friends on messenger services. Now, we regularly watch movies on our computers. The user doesn't interact with the platform; he doesn't switch between activities like checking emails and surfing the web and doesn't interact with the story. Instead, he presses play, leans back and watches the film in the exact same way he would if it were broadcast on television. The computer can, therefore, be used as a lean forward or lean back device. The distinction lies in the user's actions, not the design of the device.

The lean back experience is now available on any device, whether it's a mobile phone, tablet or computer. The fact that long-form content is commonly consumed on non-traditional platforms illustrates the enduring attraction of the lean back experience. The consumer does not want to be distracted from the story; they want to sit back and enjoy, whether they're lounging at home, at the office, on a bus or a plane.

The lean forward experience requires the user to be much more active. He clicks on a variety of built-in options, discovers new information and interacts with the content and other users. Like the lean back experience, the lean forward experience can be enjoyed on any given device. You can interact with Internet content or watch a television series on your iPad or desktop computer. Products like Google.tv allow consumers to enjoy a lean forward experience using their television set.

As the notion of content-specific-to-device continues to break down, transmedia producers need to focus on the patterns in user behaviour and opt to include both lean forward and lean back experiences that can be consumed on the myriad of available devices. You'll need to produce very different types of content and ask your audience to move back and forth between lean forward and lean back experiences. You risk losing a portion of your audience who are unwilling to make the jump.

Bespoke Television

For centuries, audiences have gathered around in specific places at specific times to hear stories. Today's audiences, on the other hand, have access to mobile devices, the Internet and 'on demand' services that allow them to choose which stories they want to hear, where they want to hear them and when.

As it happens, we've also reached the apex of a shift that began in the 1980s and 1990s when people first started to use pay-to-view options on television. Throughout this period, broadcasters and content providers increased the number of channels available to consumers, from a handful of channels to hundreds accessible via cable, satellite or IPTV packages.

The most radical change with regard to how we use television, however, has less to do with the increase in the number of channels available and more to do with the way we choose what we are going to view. Increasingly, TV audiences are opting out of a 'bouquet' of channels which airs certain types of content at certain times in favour of on demand services; these services allow them to choose the content that they wish to view by recording their favourite shows or accessing them on demand.

This bespoke television schedule is configured by consumers individually. Essentially, on demand services allow the viewer to design their own television schedule. In practical terms, we'll no longer have set packages of standard and premium channels; rather, we'll have an on demand box that will allow us to pick the shows we want to view, when we want to view them.

Inevitably, the on demand phenomenon will also prompt a transformation in how we pay for our television content. The standard television payment model involves

consumers paying a monthly subscription fee for a base channel pack and an additional fee for each additional channel or package of channels. Given an alternative to standard payment schedules, consumers have become increasingly dissatisfied with paying monthly television subscription fees for a large number of channels they rarely watch.

On demand services, on the other hand, require consumers to pay a subscription fee for a certain amount of content, or pay a one-off fee per show. More and more consumers are abandoning their pay-tv subscriptions and opting exclusively for on demand services.

What does this shift from linear to on demand viewing mean for transmedia? I believe it will have a positive effect on bringing cross-platform production into the mainstream. On demand content requires two things to achieve success in the marketplace: quality content and promotion. Where linear broadcasting guarantees even a mediocre show a pre-built audience, on demand content has to compete against countless other titles to secure an audience. If I distribute a series or a film on an on demand service like Hulu or Netflix without promoting the project, no one will see it.

In the future, producers will need to adopt a more transmedial approach in order to build their own fan base and make their content available anytime, anywhere across multiple platforms and devices. Transmedia allows producers to provide these sorts of conveniences to their fans, who are opting, more and more, out of linear broadcasting. To make the most of this shift, you need to develop a multiplatform approach which works with your community throughout the development, production, and distribution to create the necessary buzz.

Experience Design

A transmedial experience should invoke the most human elements of the storytelling tradition. From beginning to end, a transmedia story should be a social phenomenon, one which draws people together and unifies them through shared experiences. At present, the industry is obsessed with creating toys and applications which are too exclusive. They do not address the primary goal of storytelling – bringing individuals together by revealing some truth about the world around us. Like the 'Choose Your Own Adventure' stories of the 1980s, these gimmick-driven products isolate rather than connect your viewers. Well-designed alternate reality games are popular because they immerse players within the same social experience (the same way American Idol does, but on a smaller scale). The players are unified toward a common goal against a common evil.

If transmedia is to be even more successful in the future, we need to concentrate on designed experiences that are socially inclusive and which have the power to bring

people together through common interests and goals. This will require that we take more care in designing the path along which our readers and viewers access our stories. Transmedial producers have a tendency to create interactive experiences that are overly complex, which ultimately deter audience engagement across every available piece of content. We need to define the 'path' between audience access points, much like the map function on a video game, so that audience members know where they are relative to the story as a whole and where they're going, regardless of which piece of content they've accessed.

Procedural dramas such as CSI owe their popularity to the fact that their audience knows exactly what to expect from their format. These types of shows open with the bang: a crime is committed, and the audience is among its witnesses. As the investigators search for the killer, the audience is kept just ahead of their deductions by a steady stream of key information. We might see a confrontation the police weren't privy to, or a clue they overlooked; then, in the next three to five minutes, we're encouraged to solve the mystery ourselves. If our point of view was aligned with the investigators', the show would be tedious, and viewers would switch off.

This sort of experience design is relatively easy to achieve on television because you are restricted to a linear format. Transmedia narratives, on the other hand, are disseminated across multiple platforms. Without a proper 'map', piecing together so many disparate pieces of content can become a bewildering experience. Like a two-thousand piece jigsaw puzzle, audiences need the overall image to make sense of each individual piece. It's crucial that we, as transmedia producers, dedicate more time to creating a fluid path so that, whatever experience the audience becomes involved with, they know exactly where they're going.

To this end, our priority should always be rewarding our audience as opposed to ourselves. No matter how cool a platform or an experience may seem to you as a producer, your project will be more successful if you design content respective to the audience's point of view. Always ask yourself what your audience gains from each element of your property. If they spend ten seconds, or minutes or hours reading and watching and playing with your content, how are they rewarded? Keep your audience's most basic needs at the fore of your production plan; make them laugh and cry. Thrill them. Frighten them. No matter what you do, keep your audience emotionally challenged. Put simply, better storytelling is the ultimate reward.

Engagers v. Timewasters

When our most basic human needs are addressed and we are moved by a story through one emotion or another, the last thing we want to do is change the channel. It takes an incredible amount of effort to keep an audience engaged

to the degree that they don't want to do anything but hear your story. More and more, producers are opting to appeal to the audience's desire for spectacle than its needs for meaningful engagement. Reality TV and viral videos, for instance, have little if anything to do with engagement. They are curiosities which, given our ever shrinking attention spans, we've become accustomed to flicking on and off at random. We don't need to watch an entire episode of Bridezillas or Real Housewives to catch someone screaming at someone else; we only need a glimpse. Likewise, the most popular videos on YouTube are not short narratives but snippets of physical humour.

Our growing intrigue with such curiosities makes it more difficult than ever for producers to create something which engages audiences over the long term. Even though non-narrative stunts can achieve global exposure seemingly overnight, they cannot sustain an audience's attention. To build a transmedial brand, it is imperative that you create an experience that incites long-term audience engagement that spans several years or broadcast seasons.

Don't be tempted to design an instantly gratifying curiosity. Once again, imagine your property in terms of the Louvre in Paris. If you provide your audience with a simple map that outlines the path or 'corridor' your overall project takes, directs the audience via access points to your content and ultimately the narrative payoff, or 'Mona Lisa', their experience will not only be more rewarding, but it will be extended over a substantial timeframe.

Making the move from Platform to IP Funding

At present, independent producers rely upon platform-based funding, such as book or game advances, in order to develop a transmedia property piece by piece over time. Ideally, transmedia is a composite experience, not just a smattering of parts. To facilitate a more organic approach to transmedia, funders need to provide money up front so that producers have the resources to create all the complex elements of their property from the earliest stages of development.

To execute our production plan for the Collider franchise, we needed to secure funding support from private equity investors. We developed the comic, web series and mobile game to generate buzz in the run-up to the feature premiere. By adopting a multi-platform approach, the success of your brand (and your funder's investment) is no longer dependent upon the success of any one platform. Even if the film fails to reach an audience, the brand can persist on the collateral you've created via other platforms. From a funder's point of view, you are effectively co-collateralising their investment by designing, marketing and distributing a family of products.

Global Distribution

One of the goals we have for the future is to develop a global approach to transmedia distribution. If you're producing content for a mainstream audience, a more conventional approach is still the best model to adopt as you'll need contacts in your own territory who can make deals on behalf of your brand. Niche properties demand a different approach. While these specialised communities engage with content in a very intense way, they're scattered across the globe. To reach all of these disparate groups, you need a service that distributes your premium content to a host of territories. Content aggregators like Distribber, iTunes and Amazon have the capability to make your products available on demand in regions around the world.

In the past, if you wanted to distribute a piece of content such as a soundtrack, you had to sublicense the record to international distributors, who then sold the content to local labels. Having bought the rights, the label prints the CD, delivers PR and marketing campaigns, and places the product in retail outlets. In the future, distribution will be defined by content aggregators more so than format-centric distribution companies. Services like CD Baby automatically link your content to all of the major online music stores, from Spotify and iTunes to Amazon, Google Play and Rhapsody.

The task seems relatively straightforward: producers create content for a range of formats, deliver to specific platforms and access millions of possible buyers via mobile app stores. Unfortunately, even the world of apps is becoming increasingly complex. More and more technology companies are creating their own app stores, including Samsung and Google. The market is fragmenting, which means that you, the producer, will need to develop unique strings of code, deal with multiple account managers and sign more contracts.

Nevertheless, the apps industry is easier to negotiate than other sectors of the entertainment industry. If you want to place content on a video on a demand service in Europe, for instance, you'll have to choose between more than two hundred companies, most of which do not have the reach to justify your investment. Regardless of where you launch your content, it's very difficult for you to reach a majority of viewers.

If transmedia is to expand its reach among niche markets, we need a global aggregator that has the capability to unite consumers worldwide. Aggregators like the US company Distribber, for example, limit their sales to certain territories. Imagine the impact a global Distribber would have upon your own distribution strategy. Instead of licensing your feature to multiple distribution companies, you could interface with a single company that has the tools and the resources to make your film available on the majority of video on demand platforms.

As this is a young industry, there are hundreds of content on demand stores. More and more digital content stores go online every year, which means we need more aggregators – a Game Baby and an App Baby, as well as a CD Baby. Self-publishing services like Lulu.com allow you to upload a book once, and it's made available in hardcopy and digital formats for Barnes & Noble's Nook, Apple's iBook and Amazon's Kindle.

One of the reasons the conventional territory-by-territory distribution model is giving way to niche distribution is the polarisation of the industry. Big productions still require local advertising and take up the majority of media space, e.g. screens in the theatre and shelves in the book store. Producers have responded by creating more and more niche products that aren't intended to have a mainstream impact. As a transmedia producer, you'll be able to reach a niche audience, build a fan base and sell your brand regardless of what's happening in mainstream media.

Conclusion

The entertainment marketplace is overwhelmed with content, and that excess of products and devices is only going to increase. Audiences are becoming more and more fragmented, and the industry is increasingly divided between multi-million dollar mainstream productions and smaller, more specialised productions. The majority of us do not operate at the studio level. We don't have the resources to compete against these sorts of products for screen and shelf space.

We may not be able to rival major studios on their own terms, but we can reach millions of people in mainstream and niche communities using a transmedial approach. The key is to focus on your audience. Design an experience that will connect them with your content in a meaningful way. Engage their need to interact with one another, to react collectively with joy or sorrow or fear. Take control of marketing and distribution in the same way you control your creative process.

Once adjustments are made in the industry's prevailing format-based funding model to an intellectual property-based model and the number of global content aggregators increases, producers with limited means can create high-quality content and access markets around the world by way of two to three distribution agents. Build your community online, engage them across multiple platforms and convert them to buyers using a fremium model. If your property becomes a crossover hit, the big players will buy your brand and transform it into a blockbuster hit. You have reached your goal to build a hot transmedia brand when you've proven that you have a fan base and a salable concept, which studios and corporations are willing to buy.

APPENDIX

- Creating an Indie Movie Franchise
- Transmedia in Documentary Storytelling

Creating an Indie Movie Franchise Using Transmedia

Transmedia is a buzzword that has been used increasingly in the past couple of years to define all sorts of things, from the independent movie that has a companion website and a Facebook fan page to the multi-million dollar interactive experience that involves games, interactive web sites and live events. But what all these different so-called 'transmedia' projects have in common is the desire of their producers to engage an audience using digital and social media tools.

The distribution and monetisation of content in multiple platforms or media is not new. Major studios and networks have been doing it for decades. They were the gatekeepers that controlled the access to audiences; they were the ones that had the sufficient marketing power to promote their content to an audience in every single platform that became popular. What the transmedia approach and the digital platforms are bringing that is new to the table is the fact that independent filmmakers are now able, for the first time, to directly connect with their audience using social media and on-line communities without multi-million dollar campaigns.

For the first time, filmmakers can 'own the audience'. They can talk to the audience and find out what they like (or dislike). The success of their movies is not a hundred per cent dependable on a film distributor or sales agent. Using a transmedia approach to their work, directors and producers can validate their work directly with a real audience and can build a fan base and increase awareness of their project. The success of movies like The Blair Witch Project, Paranormal Activity or, more recently, Kevin Smith's Red State was the result of the buzz created by the filmmakers using the Internet and the social media services (or an ancient version of social media in the case of The Blair Witch Project). But is 'transmedia' just about promoting a movie using Internet and digital platforms?

Most of the so-called transmedia projects that were produced in the last couple of years are just that – transmedia brand extensions. Most studio and network executives see it only as an on-line marketing tool to promote, to the young crowds of moviegoers, the upcoming summer blockbusters or the new sci-fi based network TV series. But the concept of transmedia goes a little beyond that.

Transmedia is about creating a storyworld, a story that in its origin is not formatted to any specific media or format. It's not a book; it's not a film or a TV series. It is a

world populated with characters that interact with each other and create conflict and plot. It's only when that storyworld is well-defined that the producer or the filmmaker start to open windows to that world, to allow the audience to connect with the story. These windows are the different media where the story will be told. The true transmedia projects are the ones that pick the right media to tell the different parts of the stories. But does this mean that the audience needs to watch, read and interact with the story in all the different media to understand what is going on?

Yes and no. In transmedia there are two types of approach to allow the audience to connect with the story. First, there is the puzzle-based approach, where the audience needs to collect content pieces on different media, jump from one platform to the other, and then align all the content pieces to form the plot and the story. This is the approach used in alternate reality games. The advantage of this model is that it creates a very loyal fan base, with fans jumping from one media to the other and then spending long hours collecting content, deciphering codes and solving puzzles. The big problem with this approach is that it is difficult to generate big communities around this because it's a time-consuming experience (and somehow confusing to the average user that just wants to watch a funny video in a more lean back experience).

The other type of approach is what some experts call the transmedia franchise, where you still tell your story in different media, but each media is independent and lives at its own merits. A comic book may tell part of a story, the website and social media may develop a few of the characters, but a game allows you to get into the shoes of the hero and the movie takes your story to the big screen.

In a franchise approach, audiences can only watch or read one of the pieces of your content puzzle, and each standalone piece will make sense for that audience (i.e. it will have a beginning, a middle and an end). But the fans that consume every single piece of content that you release will have a better understanding of the world and story you created. They will know every single story and past event that happened to the characters before the start of the movie. Or they will know what their favourite characters did between the first movie and the sequel.

The big studios, with their summer blockbusters, are using this approach. Most of the movies released every summer are based on existing comic books (or other properties, like games or toys) and they already have an existing audience, spread through several websites and social media profiles, that connects with the content and brand all year around. And then, every few years, a new movie comes out to satisfy the demand from this loyal fan base. But now, thanks to the development of new digital media platforms, small independent producers can use the same approach and increase brand awareness of their movies and establish their own franchises.

In our productions, we always try to build small pieces of content as early as possible before the big and expensive movie (or TV series) comes out. Thanks to the popularity of the tablet and ebooks, it's now easy to release a novel or comic based on the storyworld you're creating. Remember all that backstory you wrote for your characters that never made it into the script? Releasing it as an ebook or comic book may work as a prequel to your movie, letting the audience connect with your main characters from an early stage. Or you could create a web series as a prequel to test your casting options.

Then, complement these digital releases with a social media presence to start creating buzz and getting audience feedback. You may find out that your main character is not as lovable as you need him to be. Maybe the audience is reacting in different ways than expected. If you still haven't shot your movie, you can go back and fix the script. Is your project a comedy and you're trying new talent? Perhaps you can test your material with a live audience, probably as a stand-up comedy show, where you can see how a real audience reacts to your lead actor and your jokes.

This audience interaction may give you good ideas with which to go and fix your script (or casting options). Is your project in the sci-fi or horror genre? Then probably developing (or asking a games company to develop) a game for web, Facebook or mobile and tablet platforms based on your property could be a good way to build an audience. This will probably also cost you nothing as you can do a co-production with a games studio and split the revenues.

While executing some of these ideas you're also building your audience. People are becoming aware of your brand and, if they are enjoying what you're serving them, they will share it with their friends and family. On top of that, you're getting the best feedback possible on your work. Real, live audiences are reacting to your work and allowing you to fine tune your movie – advice and reactions you will probably never get from a script editor or a test screening.

Does this transmedia approach fit all film projects? It depends on the filmmaker's plans for his work. I usually say that the transmedia franchise approach, because of the commitment in time and resources, only makes sense if you see yourself producing sequels of your original movie. If you are only interested in producing a one-off movie, a small, character-driven drama, probably the franchise approach doesn't suit you. But even so, you can use some of concepts of transmedia to build your audience, your fan base, and to feed the content development stage.

The secret is to involve your audience as early as possible. Ask for their participation, let them help, whether suggesting plot points or casting. More sophisticated approaches could be letting the audience create some elements for your movie, from posters, websites or communities. If the audience is involved in the making of your movie, they will be the first ones to want to see your (and their) work. They will be the ones promoting your movie and getting their friends and family to join them on this experience.

The big complaint I keep hearing from film producers is that transmedia is more work for less money. It's true that the majority of distributors and traditional funders will not give you any additional money for the production of the transmedia elements; but the truth is, the power of having a pre-existing audience, a loyal fan base, is probably more important for your movie. Unfortunately, we live in a world overcrowded with movies, but audiences are becoming smaller. If you have your own built-in audience of fans, you have more chances to succeed. Film distributors, sales agents and exhibitors are not just looking for good movies. They are also looking for movies with pre-built audiences.

*A version of this article was first published in May 2012 at www.mipworld.com.

Transmedia in Documentary Storytelling

Transmedia is seen by the industry as a tool (some call it a gimmick) to engage young audiences around scripted formats and franchises. It's clear that this demographic includes most early adopters of new technologies. But, with the success of new smartphones, tablets and social media services, all types of audiences are getting savvier and demanding more engaging content that they can take with them everywhere.

Looking at these recent developments in technology, we've been diversifying our slate of productions. It's true that, ten years ago, our first transmedia project was aimed at teen girls. The reason was obvious: they are big users of social media and mobile phones and they seemed the right demographic on which to try new forms of entertainment. However, since last year, we've been developing documentaries and factual TV series aimed at older audiences and applying our decade-long experience in transmedia product development. Looking at the spectrum of projects available, we wanted to do something different. Again, we wanted to put the audience in the centre of it all.

Extending a factual TV series or a documentary with additional digital content is nothing new. In the late nineties, the BBC developed some complementary content for its flagship documentaries accessible by red button technology. These offers were created around the concept of 'click to know more'. They acted like extensions of the TV documentary, providing audiences with additional information around the subjects or characters featured in the documentary. More recently, the likes of Arte in Europe and the National Film Board of Canada have been co-producing this sort of 'two-windows' documentary, where audiences can extend their TV experience with additional digital content made available on the web (or mobile platforms).

The extended documentary seems to be a popular path for filmmakers and broadcasters. Some commissioners ask their producers to generate additional content that is made available online. When producing a documentary, filmmakers generate hundreds of hours of footage, thousands of research documents and dozens of interviews that never make the final cut. Re-editing all this material is an obvious solution to create an extended digital version of the documentary. It allows audiences to find out more about the subject featured in the documentary and get additional information.

Although these extended documentaries have proven relevant and popular with audiences worldwide, we wanted to do more with our factual offers. We want to include the audience from day one of the production in the same way we do with our scripted projects. We want audiences to be part of the documentary. So, last year, when a young Irishman called Ian Lacey approached us with this crazy idea of cycling from the most northerly point of Alaska to the south of Argentina over 350 days, we had the right subject with which to start our first experience of developing a transmedia documentary: 350 South.

What excited us was not the journey. Dozens of adventurers have already cycled the same route, spending more or less the same time doing so. What excited us was the fact that we could create a documentary where audiences could be part of the production. Of course, we have used the traditional social media tools such as Facebook, Twitter and daily video blogs that audiences can follow. But we also created the right context so the documentary can be affected by audiences. We have used Spot Adventures' GPS tracking service to enable everyone to know where Ian and his cycling partner, Lee, are at any given moment.

Both Ian and Lee are available almost daily on social media, contacting viewers. And the results have started to appear. Viewers that live near the route they established have started to contact the adventurers, offering them a meal, a place to sleep or a pint in the nearest pub. They are physically interacting with the adventurers and, as everything is recorded on camera, they have become part of the documentary. Audiences also unite in cycling events, helping the adventurers to overcome some challenges and also telling their own stories. Other adventurers doing similar routes found out about the documentary and approached Ian and Lee, becoming part of the experience too.

Why is all this important to us? Because we have generated a community of fans and followers that are deeply connected to Ian and Lee's stories. They make an effort to follow them online, but also to meet them in person and so become part of the documentary. The fact that more and more people every week join the experience enriches the content and the documentary itself. At the same time, we are developing the roots for a growing community, which is part of the filmmaking process and will probably be our best marketers when the documentary is released. So far, 350 South is available online (www.facebook.com/350south) and five minute interstitials are being broadcast on TV (Setanta Sports). Later on, the documentary will be made for TV and as a book.

Most recently, and applying the experience we've gained on 350 South, we are producing Road to Revolution, a documentary about three journalists who will travel 15,000 kilometres across ten countries in the Maghreb and Middle Eastern regions, following the path of the Arab Spring. Starting in Turkey's megacity Istanbul, the Road to Revolution will cross some of the most tense and effervescent

countries on the planet – Syria, Lebanon, Jordan, Israel, Egypt, Libya, Tunisia, Algeria and Morocco. The project will start as a web doc and a weekly column in a newsmagazine and will later cross to other platforms, including TV and print as well as being made available as a feature film. The approach is similar to 350 South in that it will be using transmedia and social media tools to make the audience a part of the experience from day one.

*A version of this article was first published in March 2012 at www.mipworld.com.

Lightning Source UK Ltd.
Milton Keynes UK
UKHW010632290123
416118UK00001B/119